STAINE[GLASS AT YORK MINSTER

~

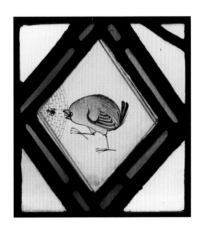

STAINED GLASS AT YORK MINSTER

~

SARAH BROWN

WITH PHOTOGRAPHY BY NICK TEED

SCALA

IN ASSOCIATION
WITH THE YORK
GLAZIERS TRUST

AUTHOR'S ACKNOWLEDGEMENTS

My greatest thanks are to my colleagues at the York Glaziers Trust, with whom I have explored the Minster's windows over many years, most particularly during the recent exciting conservation of the Great East Window. I have also benefited hugely from discussing the Minster's windows with fellow scholars, including Professor Tim Ayers, the late Dr Tom French, Professor Richard Marks and Dr Ivo Rauch. Above all, I record my thanks to Professor Christopher Norton, whose contribution to the understanding of the Minster(s) and its glass, generously and humorously shared over many years, has been outstanding. Our shared debt to the indefatigable antiquary James Torre (1649–99) is immeasurable.

Sarah Brown
August 2016

First published in 2017 by
Scala Arts & Heritage Publishers Ltd
10 Lion Yard
Tremadoc Road
London SW4 7NQ, UK
www.scalapublishers.com

 In association with
THE YORK GLAZIERS TRUST

ISBN 978 1 78551 073 1

Edited by Johanna Stephenson
Designed by Raymonde Watkins
Printed in China
10 9 8 7 6 5 4 3 2 1

FRONTISPIECE: Kneeling female pilgrim, *c.*1310–25 (N21).

INSIDE FRONT COVER: Numbered plan of the Minster's windows.

CONTENTS

6
FOREWORDS
THE RIGHT REVD. VIVIENNE FAULL, DEAN OF YORK
NICOLAS BARKER FSA FBA, CHAIRMAN, THE YORK GLAZIERS TRUST

8
FROM EDWIN'S CONVERSION TO THE TWELFTH CENTURY

20
THE TRANSEPTS

24
THE CHAPTER HOUSE AND ITS VESTIBULE

34
THE NAVE

58
THE GLAZING OF THE EASTERN ARM

86
THE END OF THE MIDDLE AGES

90
AFTER THE REFORMATION

94
THE NINETEENTH AND TWENTIETH CENTURIES

100
THE YORK GLAZIERS TRUST 1967–2017

102
FURTHER READING

103
GLOSSARY OF TERMS

104
INDEX

FOREWORDS

THE STAINED GLASS equivalent of the Sistine Chapel. That is what I learnt of the quality of the Minster's glass from my first visit to the York Glaziers Trust, which then had the Great East Window panels under conservation.

York Minster is one of the architectural glories of the world, its impact deriving from the interplay of space, stone and its 128 mostly medieval windows. These windows were designed to tell the story of the Northern Province of the English Church and its faith. The Great East Window tells of the beginning and end of all things. The Cuthbert and William windows tell of the lives of the northern saints. Nave windows tell, with humour as well as artistry, of medieval rulers and donors.

Cumulatively the glass brought a jewel-like sense to the spaces of the cathedral, conveying the glories of heaven to the misery and muddle of the city of York. The twenty-first-century visitor glimpses that too. The Minster's beauty is constantly shifting as the sun moves and the weather changes. It is a wonderful place to be still, to sit and to pray.

The windows are fragile. They have suffered in fire and from pollution and vandalism. Extreme weather increases their vulnerability. The Chapter of York, in partnership with York Glaziers Trust, is committed to a long-term programme to protect and, when necessary, restore the glass. In this task the Chapter is profoundly grateful for the commitment and skill of Nick Teed as conservation manager and YGT director Sarah Brown, whose scholarship, evidenced in this revision of her survey of the Minster's glass, is invaluable.

VIVIENNE FAULL
Dean of York

THE CHURCH BUILDINGS of this country are the oldest man-made constructions in regular use. Their needs have changed and so have the buildings, growing with them. York Minster is one of the greatest, and one of its outstanding treasures is its stained glass. Many generations have learned to admire, revere and love its glory. That indefatigable traveller Celia Fiennes, visiting York in 1697, called the Minster glass 'the greatest curiosity for Windows I ever saw', and many, before and after, have been as moved by it. That it has survived, through the Civil War, fires in 1829 and 1840, and lightning strike in 1984, is itself a miracle. During the Second World War much of the glass was removed and stored; its return and conservation was the last and greatest task undertaken by Eric Milner-White, Dean of York 1941–63. Stained glass was his passion and he took a daily interest in the opportunity it offered of putting right the casual damage and misplacement that had occurred over centuries.

It was in his memory that, with support and funding from the Pilgrim Trust, the York Glaziers Trust was set up in 1967, with a permanent workshop near the Minster. Peter Gibson, who had served his apprenticeship under Milner-White, was its first manager. While its first duty was and always will be the Minster glass, it was from the outset destined to work on glass elsewhere, and that has provided a ground-base to its main task. In the last fifty years its work has grown and changed, along with the techniques of conservation, one of the great 'growth industries' of our time. Its staff has grown from 3 to 14 and, thanks to its association with the Stained Glass Conservation master's programme at the University of York, the nature of its work has advanced, not only in technique but also in the scholarly study of the making and preservation of glass.

If our chief work since 2005 has been the restoration of the Great East Window, due to be completed by the end of 2017, we have also extended our work to many other buildings, secular as well as ecclesiastical. The expertise of our staff has grown under Sarah Brown, formerly a trustee, and since 2008 Director of the Trust.

York Minster has the largest single assemblage of stained glass from the twelfth to the eighteenth century in the country. It still offers a glimpse of the medieval vision of the church on earth as a foretaste of the heavenly Jerusalem, a translucent structure 'like unto clear glass' (Revelation 21: 18). The building of the medieval Minster and the glazing of its windows were a collaborative enterprise that brought together churchmen, kings and nobles, laymen and women and the craftsmen and citizens of York. The care of the windows continues to be a collaboration, in which the craftsmen and women of the YGT, the Chapter of York, and scholars all play their part. We hope that this book, published to celebrate many centuries of worship and work and our own fiftieth anniversary, will add to the enjoyment and appreciation of the many thousands who will follow the medieval pilgrims and admire the stained glass at York.

NICOLAS BARKER FSA FBA
Chairman, The York Glaziers Trust

FROM EDWIN'S CONVERSION TO THE TWELFTH CENTURY

THE PRE-CONQUEST MINSTER

When Wilfrid was made Bishop of York in the 660s he found the stone church dedicated to St Peter that had been begun c.627 by Edwin (c.586–633), the first Christian King of Northumbria, in a ruinous state. 'The top of the roof was too old to be serviceable any longer; water streamed through it; the windows had never been glassed in, so birds flew in and out, and built their nests inside', says Wilfrid's biographer, Eddi. Wilfrid set about restoring the damaged church, covering its roof with lead and glazing its windows. The glaziers cannot have been local craftsmen, for when in 674 Abbot Benedict Biscop (c.628–689) founded St Peter's monastery at Wearmouth, he had to send to Gaul for glaziers – 'craftsmen as yet unknown in Britain' – who then taught the English this unfamiliar art. Both Benedict Biscop and Bishop Wilfrid were adherents of the Roman tradition of churchmanship and had visited Rome itself. They consequently regarded glass windows as essential amenities for a major church. It was therefore in a very meaningful sense that the Church in the North brought stained glass to Britain.

This Anglo-Saxon cathedral remains something of a mystery and even its location has been contested, although scholarly opinion now agrees that it was probably immediately to the north of the present cathedral. We have no material remains of its windows, and literary sources offer little information as to their nature. Eddi records only that they prevented the birds from entering the church while allowing the light to shine in. Glass fragments associated with window leads have been excavated at Anglo-Saxon sites at Wearmouth, Jarrow and Escomb in Northumberland. They are variously coloured but unpainted, although some pieces have retained the grozed edges that show that they were carefully shaped to be arranged in decorative patterns. It is likely that the windows of Wilfrid's church, as yet undiscovered by archaeology, were also glazed in this way.

THE CHURCH OF THOMAS OF BAYEUX

By 1070, when the first Norman Archbishop, Thomas of Bayeux, was consecrated, the Anglo-Saxon cathedral had once again been reduced to a ruin by a fire (in 1069), said to have been caused by William the Conqueror's troops. Only three of its canons remained alive. Thomas, formerly treasurer of Bayeux Cathedral, temporarily restored the old church, but in the late 1070s he began to rebuild on a new site and on an unprecedented scale. It is this church, completed c.1100, with a short-lived eastern extension added in the early twelfth century, that lies directly beneath the present Minster and was excavated between 1966 and 1973.

1 Exuberant border designs that once enclosed the twelfth-century figurative scenes.

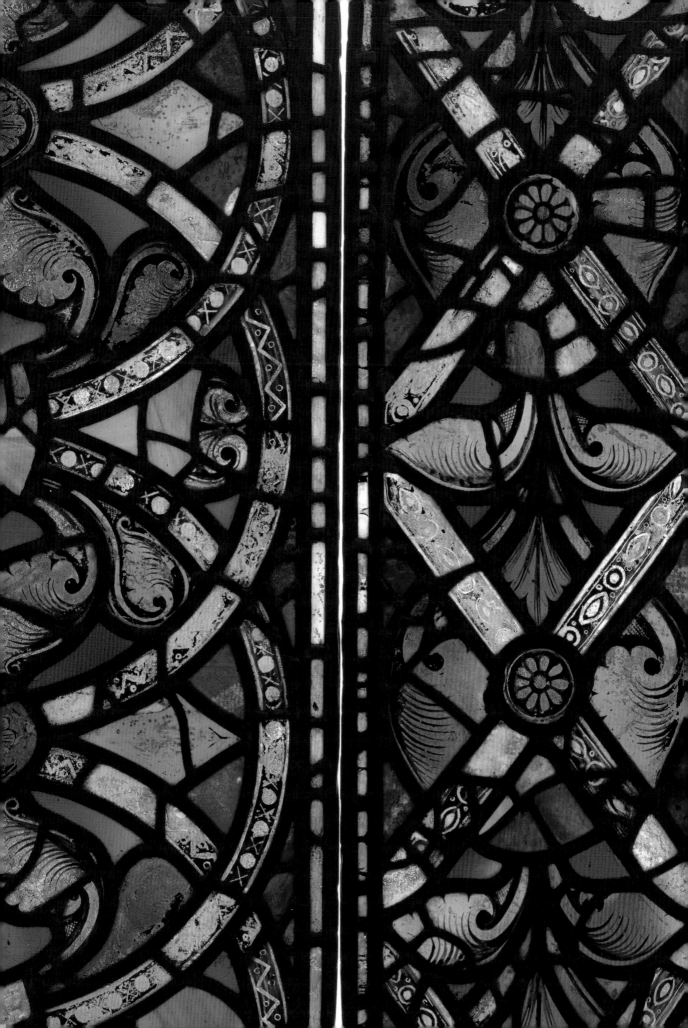

Recent research by Stuart Harrison and Christopher Norton has allowed the virtual reconstruction of this lost cathedral. Its wide, aisleless nave was lit with a large number of deep-set single lancet openings in its upper elevation, with substantial, blank walls at ground-floor level. The very long eastern arm also had a spacious crypt, lit with natural light from small above-ground windows.

No documentation sheds light on the nature of the cathedral's glazing and almost nothing of its superstructure survives. Only five fragments of blue glass that can be associated with Archbishop Thomas's original building programme, bearing traces of what might be painted drapery or foliage, have been found, excavated in the area to the north of the eleventh-century north transept. Very little European stained glass survives from the years around 1100, but the four sophisticated, monumental figures of prophets that survive in Augsburg Cathedral perhaps suggest what Thomas's stained glass might have looked like.

THE MINSTER IN THE TWELFTH CENTURY

In 1154 Roger of Pont l'Eveque (c.1115–81), former Archdeacon of Canterbury, succeeded William Fitzherbert (later St William of York) as Archbishop of York. Roger sought to enhance the prestige of the Northern Province and its cathedral by challenging Canterbury's claims to ecclesiastical supremacy in England, a policy that eventually brought him into conflict with his former friend, Thomas Becket, made Archbishop of Canterbury in 1161. This prestige was to be given architectural expression and Roger used his prodigious wealth to create one of Europe's most innovative and sumptuous early Gothic churches, its splendours only recently brought to light through new research [2].

A fire in 1154, which damaged the tomb of Archbishop William, then only recently buried at the east end of the nave, was used as an excuse for the wholesale reconstruction of the eastern arm over an extensive crypt. Roger's aisled choir was of eight bays, with rectangular north- and south-eastern transepts between the fifth and

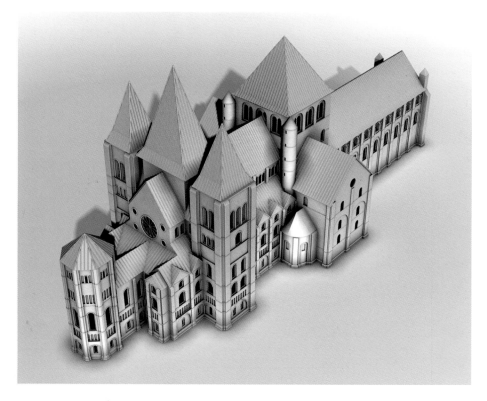

2 York Minster as it was *c*.1200, showing Archbishop Thomas's nave and Archbishop Roger's choir, reconstructed from the archaeological evidence by Stuart Harrison and Christopher Norton (computer reconstruction by Stuart Harrison).

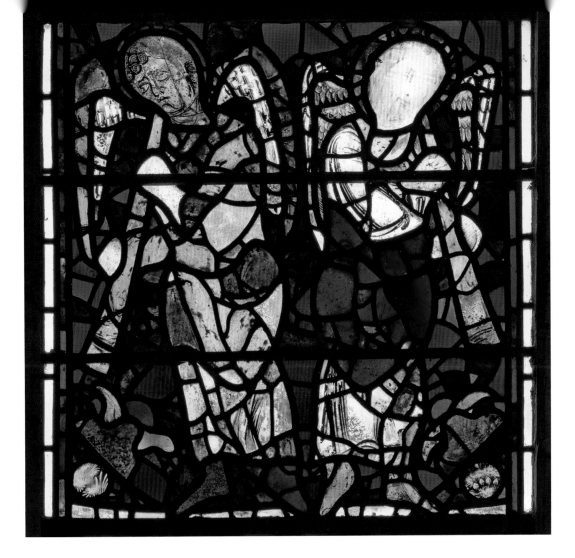

seventh bays. At the end of each aisle was a short eastern chapel. Extending further
east there is evidence for what was one of the building's most extraordinary features,
a centrally planned chapel of three storeys, a structure that pre-dated the corona
chapel of Canterbury by at least 15 years. Internally the church was decorated with
intricate mouldings and architectural sculpture, and a profusion of imported Purbeck
marble. In places the masonry was further embellished with sophisticated geometric
designs painted in up to seven colours. One of the most important differences between
Thomas's nave and Roger's choir was in the provision of light. The new building was
lit by large windows in three superimposed tiers, at crypt, upper choir and gallery
levels, and there can be no doubt that this was an excuse for a lavish display of painted
window glass. Roger completed his architectural project by remodelling Thomas of
Bayeux's transepts and adding a massive new west work to the eleventh-century nave.

While neither Thomas's nor Roger's buildings survive above ground, over fifty
panels of twelfth-century stained glass remain, reused by later Minster builders. The
largest number is located in the clerestory of the fourteenth-century nave. Like a
number of pieces of twelfth-century sculpture, the panels were reused by the Gothic
builders at high levels in the new nave, where their archaic style would have been less
noticeable; perhaps they were only ever intended to be a temporary solution. They
were cut down to fit their new locations, but were originally circular, quatrefoil and
vesica-shaped, accompanied by wide foliage borders, of which 16 sections survive.

The remains of at least six picture cycles have so far been identified, of which the
largest number (11 panels) relate to the Last Judgement [3]. There are six scenes of
events following the Resurrection [4], episodes from the lives of the saints, including

4 The miraculous draught of fishes (S26).

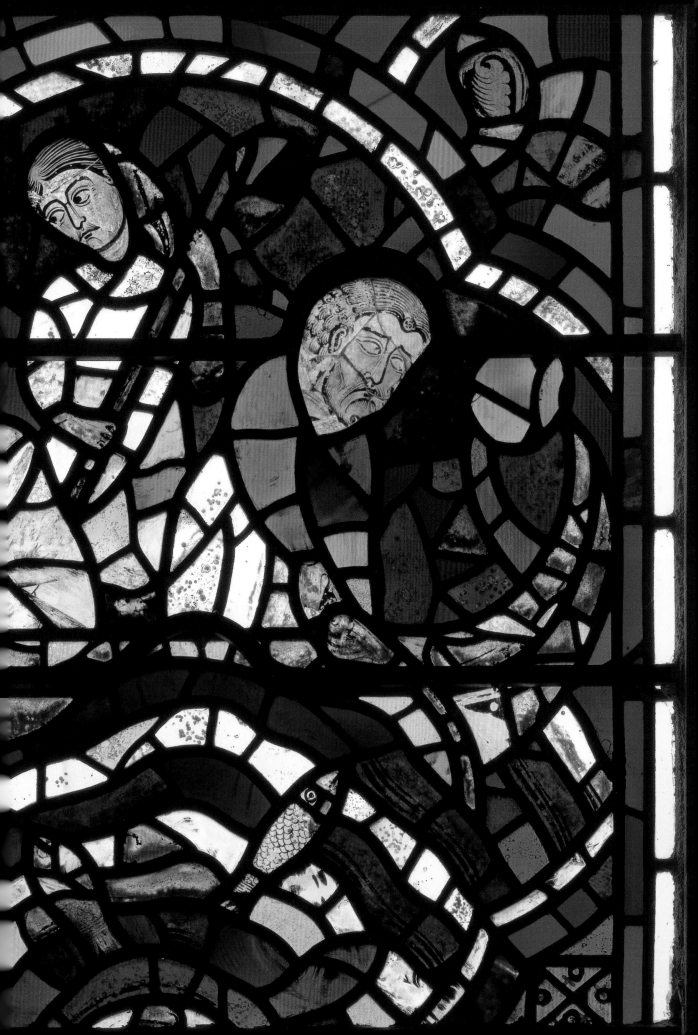

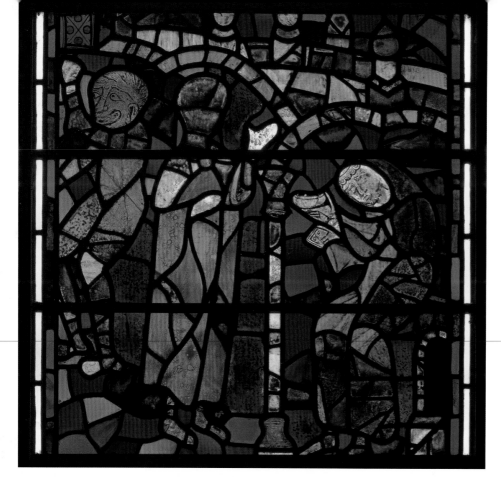

5 St Benedict fed by Romanus, a scene from the St Benedict window (S25).

6 A scene from the miracles of St Nicholas of Myra (S27).

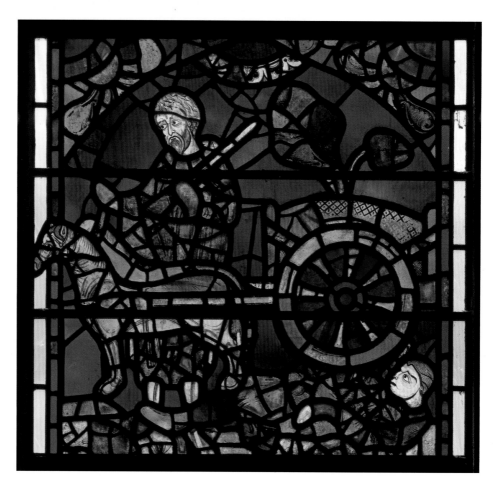

the life and miracles of Saints Benedict (three scenes [5]) and St Nicholas of Myra (two [6]), but only a single Old Testament scene (of Daniel and Habakkuk, in the Five Sisters window since the early eighteenth century [7]). A seated king of Judah is all that remains of a Tree of Jesse and is now displayed in the undercroft [8]. Four panels remain unidentified, although two have been suggested to represent the story of St Martin of Tours. In addition to the painted and coloured panels, there are numerous unpainted panels of interlacing and geometric glazing made of 'white' glass, much of it heavily patched and restored, but preserving eight different designs. Like the figured

7 Daniel in the lions' den fed by the prophet Habakkuk, now in the Five Sisters window (n16).

glazing, these panels were reused in an early fourteenth-century glazing programme, alternating with bands of coloured glass (both twelfth- and fourteenth-century in date [1]).

Recent research by Dr David Reid has questioned the traditional attribution of all the twelfth-century glass to a single location and chronological period, suggesting that it may have come from a number of different demolition contexts, as the new nave steadily replaced those parts of the Minster dating from the late eleventh to the mid-thirteenth centuries. It is unlikely, however, that any of the glass could have come from Roger's choir, which was only demolished in the years after 1394, long after the nave clerestory had been completed and glazed. Only the nave of Thomas's church, probably re-glazed in the twelfth century when its great west work was added, could have released the quantities of glass reused by the builders of the new nave, although the widening of the nave in the fourteenth century could also have necessitated the remodelling of Archbishop Roger's Chapel of the Blessed and Undefiled Virgin Mary and All the Angels (also known as St Sepulchre's), which lay to the north of the nave.

Whatever its exact date and place of origin, what is beyond question is that the York glass is of exceptionally high quality in terms of materials and workmanship. Both its style and its iconography reveal that the York glaziers were anything but provincial in their outlook and associations. Many years ago the late Dr Peter Newton showed that the three scenes from the life of St Benedict are indebted to an eleventh-century life of the saint made for the Benedictine Abbey of Monte Cassino (Vatican Library, Cod. Lat. 1202). A scene very similar to the York panel depicting St Benedict in a cave fed by Romanus [5] was also depicted in glass c.1144 at Abbot Suger's famed abbey of Saint-Denis near Paris (a panel now in Raby Castle chapel). In the absence of any very substantial material from the first half of the twelfth century in English churches, art historians have turned to glass of the 1140s–50s from the abbey of Saint-Denis and to the cathedrals of Chartres and Le Mans for comparisons with figurative and decorative glazing at York. In its symmetry and the disposition of foliage, for example, the York Jesse Tree panel [8] closely resembles the famous Jesse Tree in Abbot Suger's Saint-Denis (c.1145) and the similar Jesse Tree in the west façade of Chartres Cathedral (c.1145–55). The York panel is thus the earliest surviving example of this subject in English stained glass. The figurative panels at York were set in the midst of sumptuous and richly coloured borders of a fleshy, acanthus-like foliage [1]. In common with the narrative panels, they display a wide palette of glass colours, of a soda-rich composition that has made them remarkably resistant to corrosion.

The work of Norton, Harrison and Reid has substantially revised our views of the qualities and character of York architecture, sculpture and stained glass in the late eleventh and twelfth centuries. Thomas's and Roger's churches [2] were innovative, distinctive and of outstanding quality. Nor is it any longer necessary to look for European models to explain the qualities of English stained glass produced in the same period. In the 1140s Abbot Suger sought out the best glaziers in Europe to make his windows and it is entirely conceivable that York craftsmen were among them.

The loss of Thomas's and Roger's buildings makes it difficult to reconstruct the original disposition of these twelfth-century panels. The arrangement of Last Judgement panels presents particular difficulties, as it is a comparatively rare subject in narrative lancets at this date. While an oculus has been considered by some authors, the two panels containing groups of apostles [9] require a central figure of Christ, only possible in a horizontal arrangement three panels wide. Three panels, with borders, would have required a window of considerable size, and a window in

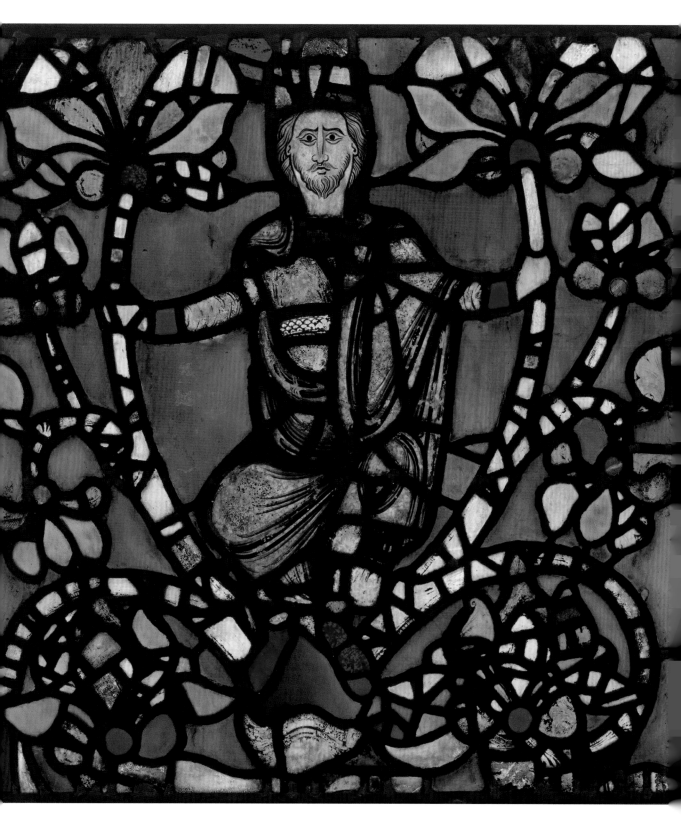

8 A king of Judea from a Tree of Jesse
window, c.1145 – 50, now displayed in the
Minster undercroft exhibition. The king's
head is a modern restoration.

9 Twelfth-century figurative panels (seated apostles [left]
and trumpeting angels [right] from the Last Judgment),
set into unpainted geometric grisaille (S23).

Roger's west work, between the western towers, is a possibility that is also borne out by the archaeology of the robbed-out foundations. A west wall is also a common location for a Tree of Jesse, although in the fourteenth-century nave this subject was located in the south wall and the provision of rich figured glazing for the large lower windows of the aisle-less nave of Thomas's church cannot be discounted.

The collection of unpainted geometric grisaille reused in combination with the figurative glass in the fourteenth-century nave clerestory deserves special attention [9]. This kind of glazing enjoyed a long period of popularity and at Salisbury Cathedral, for example, continued in use into the second quarter of the thirteenth century. Indeed, three of the York patterns are closely related to designs at Salisbury. This type of glazing was probably once quite common wherever simpler and lighter windows were required, although it was also commonly associated with the Cistercian Order, which, from the middle of the twelfth century, prohibited the use of coloured and painted window glass in its churches all over Europe. Close parallels to the York panels are to be found among surviving Cistercian glazing schemes. Two York designs are almost identical to patterns in windows in the French Cistercian churches at Obazine, La Bénissons-Dieu and Pontigny. The design of interlocking circles at York is also found in a late twelfth-century Benedictine context at Orbais. The eight York designs [10] are distinctive in eschewing all coloured accents, relying on the precision of the glass cutting and the strong, graphic line of the lead calmes for their decorative effect. This deceptively simple style of glazing demands exceptional glazing skill, as any inaccuracies in setting-out, glass cutting and glazing are immediately apparent.

The collection of grisaille at York represents an important addition to our knowledge of this kind of glazing and suggests that its designation as a Cistercian glazing form is rather misleading. In salvaging it, restoring it and installing it in the fourteenth-century nave, the builders of the Gothic Minster were unwittingly preserving examples of a now rare form of medieval glazing.

10 Eight geometric unpainted grisaille designs, probably twelfth century, reused, with additions, in the early fourteenth-century nave clerestory (drawing by Janet Parkin after David Reid).

THE TRANSEPTS

THE MINSTER was extraordinarily lucky with its medieval archbishops, counting a number of able administrators, talented politicians and far-sighted and generous benefactors among them. After the turbulent episcopacy of Geoffrey Plantagenet (1189–1212) and an interregnum of three years, Walter de Grey, loyal servant of King John, was translated from the see of Worcester in 1215 to become the longest-serving and most influential of York's thirteenth-century archbishops. Like Archbishop Roger before him, Walter (1215–55) strove to enhance the prestige of his see and stabilise and enrich his Chapter, an agenda in which his cathedral building had its part to play. During his tenure a new period of building activity began, resulting in the reconstruction of the transepts and crossing on a much larger scale, which stand today as the earliest part of the Minster visible above ground. It is also from this period that the earliest *in situ* glazing survives [11].

It might be wondered why Archbishop de Grey and his Chapter rebuilt the centre of the cruciform building. The new choir was not yet 50 years old when funds and building materials for the new work began to be assembled in the 1220s, and the nave, while old-fashioned by thirteenth-century standards, had been enhanced by the addition of new western towers and probably refurbished with new stained glass. The explanation is that Walter sought to complete the cathedral church with transepts appropriate to its status and grandeur and to provide an appropriate approach to the burial place of the newly canonised Archbishop William Fitzherbert (d.1154), laid to rest at the east end of the nave. Despite attempts to promote the sanctity of William in the 1170s, York was still disadvantaged by the lack of a 'resident' saint. Those saintly men associated with the see and the city, especially those made famous in the pages of Bede's *Ecclesiastical History of the English People*, Paulinus, Chad, Wilfrid, Oswald and John of Beverley, had all died away from York and had been buried elsewhere. Throughout Europe the thirteenth century was a period of great activity associated with saints and their shrines, a process with which Archbishop de Grey and Dean Roger de Insula would have been very familiar. In 1220 Lincoln, where Dean Roger had very recently served as Chancellor, secured the canonisation of Hugh of Avalon. In the same year Canterbury translated St Thomas Becket (canonised in 1173), to a new shrine in the newly rebuilt Trinity Chapel of the cathedral, a ceremony attended by Archbishop de Grey. In 1213 Beverley began a building programme that provided St John of Beverly with a new shrine setting, and in 1223 nearby Ripon translated St Wilfrid to a new shrine. In this climate of episcopal sanctity, Archbishop de Grey was quick to act to

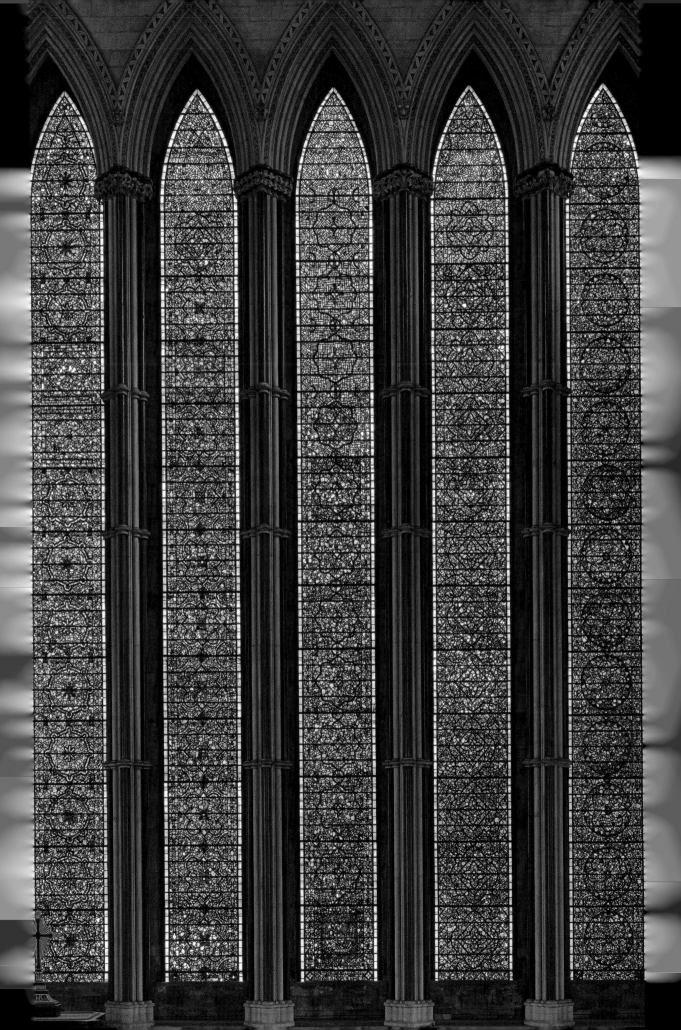

secure a saint for York by reviving William's claims to sainthood – in 1223 sweet-smelling oil was once more reported to have flowed from William's tomb and in 1227 Pope Honorius III declared William a saint whose feast day was to be celebrated on 8 June.

The rebuilding of the transepts was under way by the mid-1220s, in a campaign that saw them lengthened and deepened by the provision of both east and west aisles. Work started on the south side, with the main façade that faced into the busy city. By about 1235 work had reached the central tower, retained at its lower levels, but topped by a new belfry associated with the patronage of de Grey's successor, John le Romeyn, and by about 1255 the north transept was probably complete. The transepts had always provided the essential means of circulating around a building with an aisleless nave, but now also provided a spacious assembly area for the pilgrims gathering to visit the tomb-shrine of St William. This remained a place of pilgrimage throughout the Middle Ages, even when the main shrine had moved to a place of honour behind the high altar. The busy crossing area was also to become one of the most popular places of burial in the medieval Minster.

Archbishop de Grey took personal advantage of the passage of pilgrims through the south portal on their way to William's tomb. In 1241 he founded a chantry for the souls of himself and his predecessors and successors in the chapel of St Michael in the central bay of the south transept's eastern aisle and in 1255 was buried there, in an eye-catching tomb with a shrine-like superstructure [12]. His successors, Sewal de Bovill (d.1258), Godfrey de Ludham (d.1266) and deans Roger de Insula (d.1235) and Walter de Langton (d.1279) followed his example in choosing the eastern chapels of the south transept for their tombs, creating something resembling a clerical mausoleum there.

The master mason responsible for the new transepts combined features of northern and southern English Gothic, creating a highly textured architectural surface. Contrasting effects of light and dark were introduced by the extensive use of dark shafts of Purbeck marble, an imported material already popularised at York by Archbishop Roger's use of it in the choir. While the south transept façade has a large doorway and was altered in the course of construction to accommodate a striking rose window, the north façade, facing the area of the Close reserved for clerical residences, has no major portal and is dominated by the five great lancet windows known as the Five Sisters. It is this enormous expanse of glass that would have confronted the pilgrim or visitor entering by the south door.

How, then, were the windows of the transepts glazed in the thirteenth century? Today the eastern chapels contain fifteenth-century figures of the saints honoured at the altars nearby; we can speculate that this is an updated version of the sort of glazing favoured in the thirteenth century, although with two narrow lancets per bay there is no single opening for a patronal figure. We have seen how the choir, and probably the nave, had been filled in the twelfth century with richly coloured figured panels framed by deep borders filling the entire width of the windows with glowing colour. Based on the evidence of the Five Sisters (n16) and a few fragments of thirteenth-century glass in the western aisle of the south transept (s25 and s26), we can appreciate that the stained glass of the transept windows was strikingly different, in the latest fashion and created on an unprecedented scale. In their pristine state the lancets of the Five Sisters confronted the visitor with a towering, shimmering cliff of silvery white glass, a form of glazing known as grisaille, in which uncoloured 'white' glass is cut into intricate geometric shapes and is decorated with trails of stylised painted foliage with only limited amounts of accenting colour. The predominantly monochrome aesthetic of the architecture was thus echoed in the glass. The symbolic significance of this great wall of glass would not have been lost on the educated Minster visitor, for in the Five Sisters Window the Minster emulated the appearance of the Heavenly Jerusalem as described

in chapter 21 of the Book of Revelation, better known in the Middle Ages as the Apocalypse: 'And the building of the wall thereof was of jasper stone: but the city itself pure gold, like to clear glass' (verse 18).

Today the full impact of the grisaille of the Five Sisters is sadly diminished by the effects of dirt, corrosion and the introduction of mending leads. In 1847 the Minster historian John Browne published coloured drawings illustrating all five of these sophisticated designs [13], revealing their original splendour. Compared, for example, to grisaille glass of similar date at Lincoln, the Five Sisters grisaille is characterised by a sinuous quality. A structure is supplied by the overlying cusped geometric shapes, picked out in blue and red glass, with smaller quantities of green and yellow. The foliage, painted in bold, expressive brush strokes, depicts a variety of leaf forms, together with clusters of fruit, enclosed within beaded borders. The cross-hatched backgrounds are characteristic of grisaille glass made in the first three-quarters of the thirteenth century and only in the last quarter of the century did unpainted backgrounds became more popular.

Although the glaziers were working predominantly with white glass, a cheaper material than the imported coloured glass used relatively sparingly in these windows, it would be a mistake to regard them as 'cheap' windows. While the repetition of five designs through the full height of each light would have reduced the amount of cartooning required, the immensely skilled cutting, painting, firing and leading of these complex designs required extraordinary expertise and astonishing precision, representing a considerable glazing achievement. The grandeur of these sparkling lancets can still be appreciated on a sunny day and their impact on the thirteenth-century viewer can easily be imagined.

13 John Browne's nineteenth-century drawings perhaps give the best impression of the quality of the design and execution of the grisaille filling the five lancets of the Five Sisters (here the designs of lights a, d and e of n16 are illustrated).

THE CHAPTER HOUSE AND ITS VESTIBULE

I T IS in the Chapter House, with its seven large five-light windows, that the narrative potential of stained glass was first fully exploited in the Gothic Minster. This is in many ways the culmination of English polygonal Chapter House design [14]. Its octagonal form has dispensed with the central column that characterises the two buildings that it otherwise most closely resembles, the chapter houses of Westminster Abbey (complete by 1254) and of Salisbury Cathedral (completed *c.*1270). No documents referring to the building of the York Chapter House or the glazing of its windows have survived. The somewhat awkward way in which the door to the vestibule cuts through the architecture of the north-east corner of the north transept, cleverly disguised though it is, suggests that the builders of the earlier transepts had no plans for such a structure and that some years had elapsed between the two building campaigns. Architectural historians have long recognised the degree to which its designers were familiar with the most up-to-date European buildings of the day, including the collegiate church of Saint-Urbain in Troyes (begun in 1262). By 1289 the reconstruction of the Minster's nave was already being contemplated and by 1291 it had been begun, by which time the Chapter House and its vestibule are likely to have been complete. Indeed, in 1286 Archbishop John Romeyn was able to declare his intention of holding a visitation in the Chapter House and in 1296 it was the venue for a meeting of Parliament.

Through its abandonment of a central supporting column and a stone vault in favour of a wooden vault suspended from a steeply pitched roof, the York Chapter House represents an audacious and unprecedented transformation of a well-established English tradition, creating an enormous uninterrupted space under an apparently unsupported vault, in which the windows have massive visual impact. Although it cannot be proved that the stained glass had been installed by this time, heraldic and stylistic evidence suggests that the windows of the Chapter House had been glazed in this period, with the vestibule windows installed very quickly afterwards.

The Chapter House windows established in England a new approach to stained glass design, an arrangement often called the 'band window', in which light grisaille and coloured figured panels alternate in horizontal rows. The glaziers thus successfully illuminated the building, used on a daily basis for the transaction of Chapter business and from time to time for great matters of state, without sacrificing the potential of the windows as a vehicle for storytelling. This horizontal banding became the standard approach to window design in the closing years of the thirteenth century and persisted for well over a century.

The majority of figured panels in the Chapter House windows are enclosed in geometric frames, many of them a version of the cusped quatrefoil [15]. This was a

14 The extraordinary drama of the interior of the Chapter House (photograph by Sean Conboy).

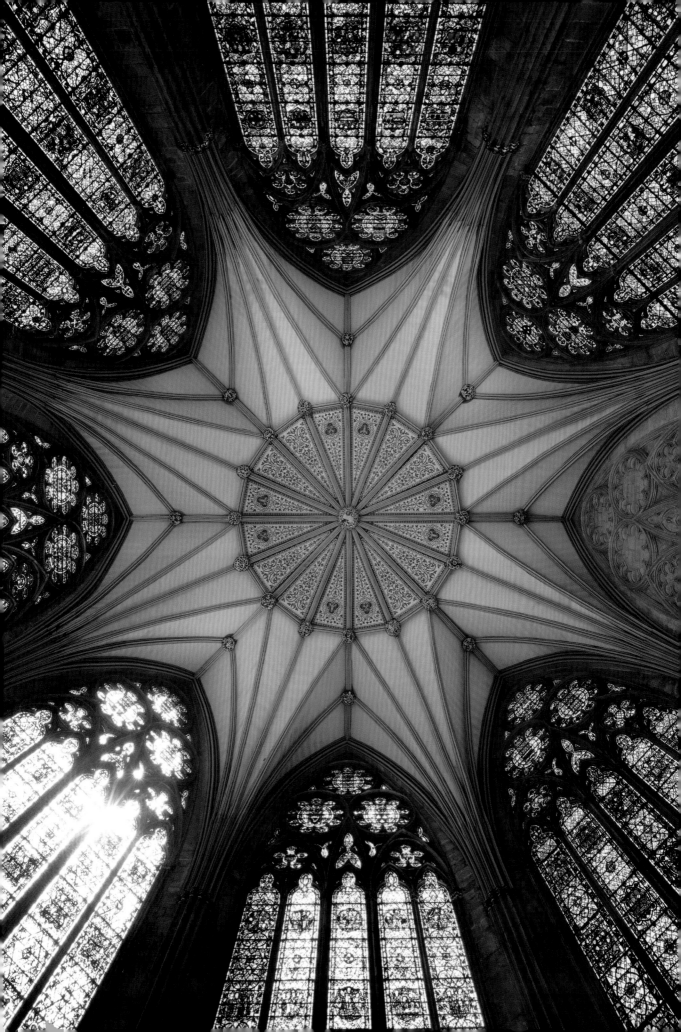

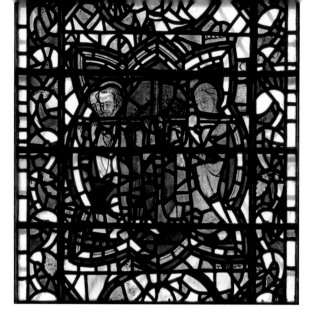

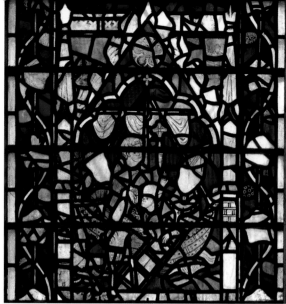

common device used in Gothic art of this date; similar frames enclose narrative panels in stained glass of *c*.1280 depicting the life of St Katharine in the apse at La Trinité in Fécamp (Normandy), in the Bible window made for the Dominican church in Cologne of *c*.1280 (now in Cologne Cathedral) and on the embroidered Clare chasuble of *c*.1272–94 (now in the Victoria and Albert Museum). By the time the vestibule was glazed, this framing device had given way to an architectural canopy that emulated the shrine-like micro-architecture of the canopied stalls lining the building's walls. In a single light of window s4 in the York Chapter House this momentous transition can be seen taking place [16]. Tim Ayers's recent re-dating of the more advanced canopied figures in the windows of Merton College Chapel in Oxford to *c*.1305–12 makes the York Chapter House glazing an exceptionally early, if not the earliest, English use of the architectural canopy to frame figures in stained glass. The canopy rather than the quatrefoil frame is used throughout the vestibule, being ideally suited to the tall, narrow proportions of the window openings.

The grisaille panels in the Chapter House are also of considerable interest and importance. In common with most of the architectural sculpture, the foliage depicted is naturalistic, in contrast to the conventionalised 'stiff-leaf' of the transepts. Recognisable leaf forms (maple, oak and ivy) spring from a central vertical stem growing out of the mouth of a dragon at the base of each light [17]. A similar device is used in the earliest windows of the nave. Geometric patterns are still, however, carried in the leading patterns. Borders are narrow and filled with climbing foliage winding around a vertical shaft.

THE HERALDRY

The Chapter House windows are also notable for their display of heraldry. All seven of them contain shields of arms in their tracery lights [18], and heraldry also appears in some of the vestibule windows. Heraldry became conspicuous in architectural decoration and stained glass in the second half of the thirteenth century, the period in which the formal roll of arms was evolving as a means of recording those participating in great gatherings of state, tournaments or military campaigns. King Henry III, for example, ordered armorial stained glass in great quantities, and although many shields of arms seem obscure to the modern visitor, their message would have comprehensible to the ⌐ been medieval eye, the medieval equivalent of the modern logo. The inclusion of a shield in a window was a means of acknowledging a benefaction or an allegiance, and of encouraging or flattering the temporal lords whose support was essential to the success of the Minster's architectural projects. It was also a means of holding an individual or a family in the memory of an institution, and the Chapter House was the place where the faithful departed were recalled in prayer and through the reading of obit lists. This is the earliest heraldic display in the Minster and is dominated by the arms of the King, in whose service many members of York Minster's clergy enjoyed advancement and prosperity.

The damage sustained by the Chapter House windows during and after the Civil War of the seventeenth century, and the replacement of some of the shields in the eighteenth century, make any interpretation of the precise meaning of the armorial display in the glass somewhat speculative. It is conceivable that the windows acknowledge gifts made to the fabric fund, perhaps even gifts made specifically for the glazing. The heraldry is helpful in confirming the date by which the building was

18 The tracery of each Chapter House window contains the heraldry of the king and his nobility. In the east window the arms of King Edward I are accompanied by those of his brother, Edmund 'Crouchback', Earl of Lancaster, the Earl Marshall, the Earl of Warwick and the Bulmer family.

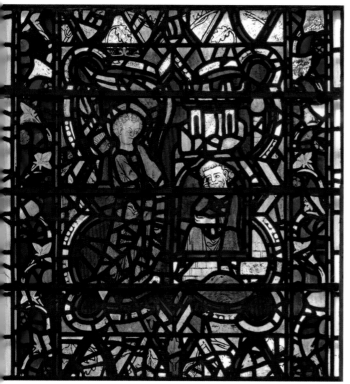
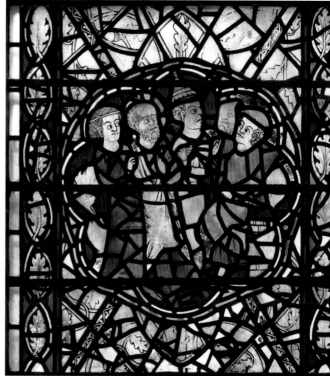

19 St Peter in prison,
c.1290 (CHs2).

20 St Paul brought
before the magistrates
(CHs3).

complete and refers to King Edward I (d.1307) and his court. Edward's arms (*gules, three lions passant guardant or*) appear 13 times. The second most frequently depicted arms are those of the King's brother, Edmund ('Crouchback'), Earl of Lancaster, who died in 1296. The presence of another shield of arms, that of John Balliol (in CHs3), suggests a date before 1292. In that year, and with King Edward's support, Balliol was crowned King of Scotland and would have adopted the Scottish royal arms.

Some of the family lines commemorated in the Chapter House glass had failed by the early fourteenth century; Brian Fitzalan of Bedale, for example, whose arms appear in both the Chapter House and vestibule, died in 1306 leaving only daughters. The shields in the windows of the Chapter House therefore offer a heraldic 'snapshot' of a very specific period in English history, when England flourished under Edward I and York emerged as a second capital city.

THE SAINTS

The main function of the windows of the Chapter House was to honour the saints most important in the devotional life of the Minster. Some of them, notably the Virgin Mary, had an almost universal appeal in the Middle Ages, although three – St Peter, St Paul and St William – were of especial significance to the Minster. The choice of subject matter depicted in the Chapter House windows must have rested with the Chapter, and in a number of instances there is reason to believe that the personal devotional preferences of the canons may have played a part. Whatever the factors that influenced the selection of scenes, the result was a sophisticated and coherent display that reflected the devotional preoccupations of the medieval cathedral Chapter, which survived the sixteenth-century Reformation and Civil War of the seventeenth century. Until the restoration of 1844–5 the east window was filled with thirteenth-century scenes of Christ's Passion and Resurrection. The nineteenth-century restorers replaced the medieval narrative panels with accurate copies [96], and all but one of the medieval panels have since disappeared. In 1959 Dean

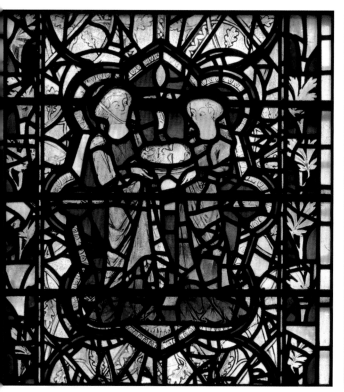
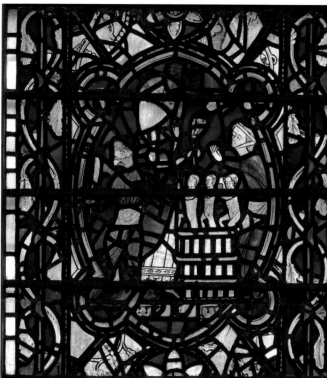

Milner-White ordered the removal of the nineteenth-century panels from the east window, which were removed to the nave clerestory. Their place was taken by a collection of fifteenth- and early sixteenth-century panels, some of which originated outside the Minster, a decision that sadly disrupted the iconographic and stylistic consistency of the Chapter House glazing.

The Passion and Resurrection window was flanked by windows dedicated to the Virgin Mary (CHn2 [15]) and St Peter (CHs2 [19]), St William (CHn3) and St Paul (CHs3 [20]) and St Katharine (CHn4). In window CHs4 the mould of a single window for a single saint is broken and five saints are commemorated, one per light: St Thomas Becket [16], St Margaret, St Nicholas of Myra [22], St John the Baptist [21] and St Edmund, King and Martyr. A window dedicated to Christ's Passion and one honouring the Virgin Mary, depicting her part in Christ's infancy and the events surrounding her own death, funeral and assumption, would be automatic choices in any great medieval glazing scheme. The cathedral is dedicated to St Peter, the subject of window CHs2. St Paul (CHs3) is frequently paired with St Peter and appears with him on the archiepiscopal seal from the time of Walter de Gray onwards. St William (CHn3) had been canonised in 1227, but his cult received further promotion at the time of the translation of his relics in 1284, an event attended by the King. Altars and chantries dedicated to a number of the other saints who are depicted in the Chapter House windows are known to have attracted personal benefactions from members of the late thirteenth-century Chapter: Gilbert de Sarum, sub-dean, had founded a chantry c.1285 at the altar of St Katharine, the subject of CHn4. St Nicholas (CHs4 [22]) was honoured by William Greenfield, who by 1287 held a Minster prebendary and in 1304 became Archbishop. The altar of St Thomas Becket, honoured in CHs4, was at the north-west crossing pier, at which Precentor Peter de Ros (1289–1312) had founded a chantry.

The Chapter House windows suffered some damage in the seventeenth century, probably during the Civil War, and some repairs had already taken place by 1658. Both stained glass and architectural sculpture have been more seriously damaged on

21 Salome and Herodias with the head of St John the Baptist (CHs4).

22 St Nicholas of Myra restores to life three boys from the pickling tub (CHs4).

the north side than on the south – perhaps as Puritan iconoclasts moved round the building from left (north) to right (south), losing enthusiasm for their work as they went. Subsequent deterioration and restoration in the eighteenth and nineteenth centuries have taken their toll and the windows are in some instances difficult to decipher as a result of paint loss, heavy mending leads and general disturbance. The windows were removed for safety during the Second World War, and under Dean Milner-White's direction were re-installed in a different narrative order. Nonetheless, the vigorous painting style and the simple but effective compositions stand out. The figures are short and almost doll-like, silhouetted against the rich colour of the backgrounds. Heads are large, with simply painted but expressive features, easily legible from the ground. These characteristics can still be appreciated in the best-preserved panels.

THE PAINTINGS

The modern visitor to the Chapter House now sees colour only in the windows. In the Middle Ages, however, the Chapter House was one of the most colourful and richly decorated parts of the Minster, its faded splendour attracting the attention of a number of eighteenth-century antiquarian draughtsmen [23]. The rippling architectural canopies dripping with exuberantly carved foliage that overhang the canonical stalls were coloured and gilded. The original wooden vault, removed in 1798, was painted with a scheme that complemented and extended that of the windows. Fanciful drolleries and grotesques, heraldic devices and decorative motifs accompanied large-scale figures of saints and angels that occupied the most prominent vault webs between each window [24]. Most of the figures can be identified from James Torre's descriptions of c.1690 and echo the subjects of the windows: St Peter, St Paul, St William(?), St Edmund, St John the Baptist and St Katharine were accompanied by Moses, St Mary Magdalene and the allegorical figures of Synagogue and Ecclesia. An unidentified female saint probably represented St Margaret, who so often accompanies St Katharine, as in window CHs4. The figure of Synagogue and upper halves of St Edmund and St William have been preserved.

Probably by the same workshop as the vault paintings were the life-size figures of what Torre described as 'archbishops and princes' painted in two superimposed tiers in the blind window tracery above the door. In the disposition of figures one above another, the painters anticipated the development of later stained glass design in the nave and choir, although the figures, set against diaper backgrounds, do not seem to have been framed by architectural canopies. Their attributes are insufficiently specific to allow them to be identified, but Wilfrid, Paulinus, John of Beverley, William, Thomas of Bayeux, Roger of Pont l'Eveque and Walter de Grey would all have been candidates for a depiction in any commemoration of significant historical benefactors, together with the benefactor Ulph and kings Edwin, Oswald and even Henry III. As we shall see, an interest in historical figures from York's illustrious past is a recurrent theme in the later windows of the nave and choir.

Immediately above the Chapter House door are 13

[handwritten margin note: Grey of gra above]

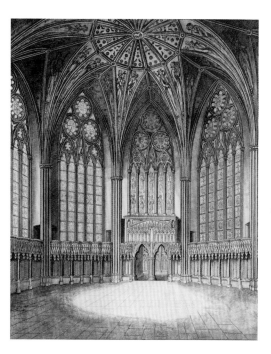

23 Joseph Halfpenny's view of the Chapter House interior as it looked c.1795, when painted glass, painted vault and painted wall survived largely intact.

small architectural niches, reminiscent in scale of goldsmiths' work. These once contained stone statues of Christ and the 12 apostles, probably painted to resemble precious metals. A comparison with metalwork is perhaps not too fanciful, for in its pristine state the Chapter House interior would have resembled the interior of a jewelled casket, a reliquary in which members of the Chapter could contemplate the life and redemptive Passion of Christ, the sanctity and intercessory power of his mother, the lives and miracles of the saints most revered by the Minster and the souls of its greatest benefactors.

THE VESTIBULE

Images and ideas first expressed on the vault and in the blind tracery over the Chapter House door recur in the windows in the vestibule that lie beyond its richly decorated doors. Images of Synagogue and Ecclesia, for example, reappear in vestibule window CHs6. The tall, narrow windows of the vestibule take full advantage of the figure and canopy formula used experimentally inside the Chapter House only in a single light of CHs4, while the idea of placing one tier of figures above another, as in the blind tracery, is also developed. Archbishops and kings, and a display of heraldry, were all significant aspects of the decoration of the vestibule, while in windows CHn7 and CHs7 heraldry has moved down from the tracery into the main lights of the windows.

24 Halfpenny's drawing of an archbishop (?St William) and the allegorical figure of Synagogue, together with grotesques decorating the Chapter House vault, before their removal c.1798.

The disturbance of the windows by later restorers and problems in identifying all the figures make the identification of an overall, coherent theme difficult to establish. It is clear, however, that a number of windows express some of the ideological themes increasingly preoccupying the court of Edward I. In 1291 Edward began to gather evidence to substantiate his claim to overlordship of Scotland and his right to arbitrate in the disputed succession, and these preoccupations made themselves felt in York, which from 1298 became the headquarters of the Exchequer and the administration of the Scottish campaigns. Vestibule window CHn8, for example, contains images of kings and queens [25], unidentified, but probably intended to represent Edward I, Queen Eleanor (d.1290) and their predecessors. The adjoining window (CHn9) contains saintly kings of England, including Edward the Confessor, Oswald and probably St Edmund. Edward I had a particular devotion to Edmund and images of both Edmund and Edward the Confessor were depicted on banners carried into battle in Scotland. In design these two windows also bear a significant resemblance to a group of tiles depicting a king, a queen and an archbishop, possibly made in the 1290s for the ambulatory pavement near Queen Eleanor's tomb in Westminster Abbey (now in the British Museum).

The saintly kings on one side of the vestibule were matched by saintly clerics on the other (in CHs5). Four deacon saints [26, 27] stand above four bishops, abbots or archbishops. St Edmund Rich of Canterbury is one of the archbishops and the other could well be St Thomas Becket of Canterbury. One bishop or abbot cannot be identified, while the other is labelled S[anctus R]obert, perhaps for the Yorkshire-born Cistercian Abbot Robert of Newminster (d.1159), but more likely to be Robert Grosseteste, Bishop of Lincoln (d.1253), whose canonisation was unsuccessfully sought in 1261, 1285, 1288 and 1307. One of his most active promoters was Archbishop John Romeyn of York (1286–96), a former precentor of Lincoln. It was with Archbishop Romeyn's encouragement that the next phase of the Minster's building history began.

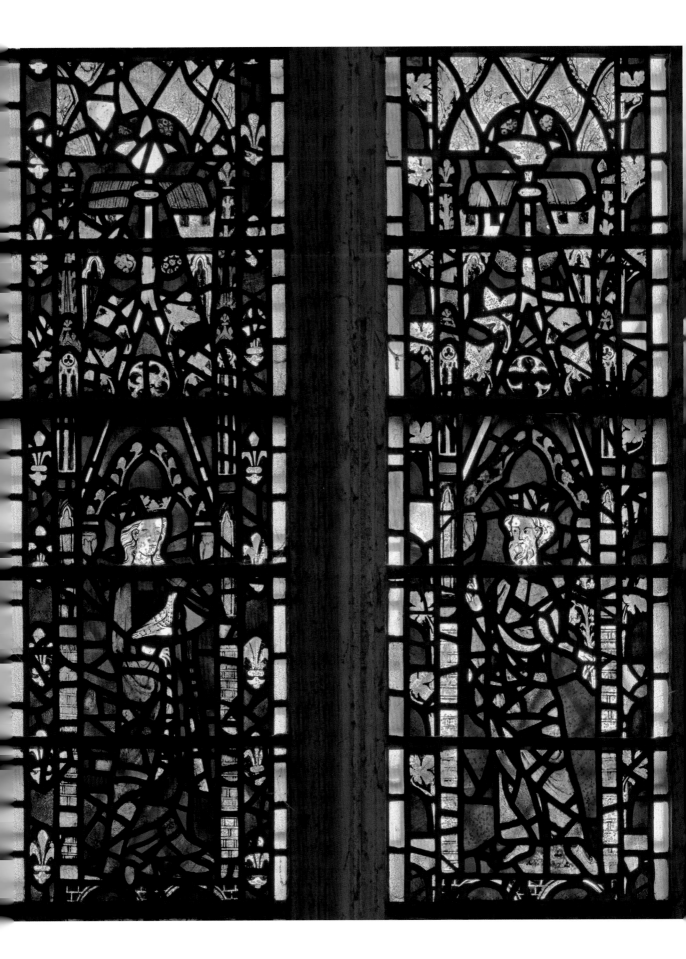

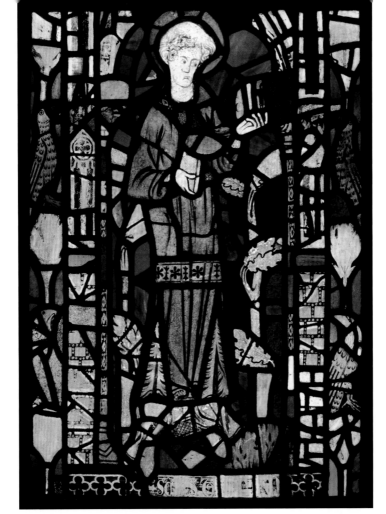

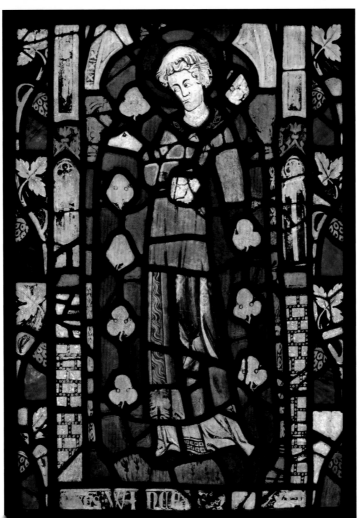

Opposite
25 A king and queen (Edward I and Queen Philippa?) in vestibule window CHn8.

Left
26 Saint Stephen in the first light of CHs5.

27 Saint Vincent in the fourth light of CHs5.

THE NAVE

B Y 1289 preparations had begun for the replacement of Archbishop Thomas's eleventh-century nave. References to the ruinous and prostrate condition of the old nave are likely to have been exaggerated, but in December of that year the buildings of St Peter's school on the south side of the nave were cleared away to make room for the greater width of the new building, with its north and south aisles. On 6 April 1291 Archbishop John Romeyn (1286–96) was able to lay the foundation stone of the new nave at its south-east corner.

Progress on the new building was initially swift; the widely spaced main arcade rests on the foundations of the outer walls of the exceptionally well-built Norman nave, saving the masons a considerable amount of preparatory work. The new broad aisles, in contrast, lay on open ground. By 1300 the area around St William's tomb at the east end of the nave was again in use and by c.1315 the two aisles had probably been completed. Archbishop Romeyn was a Paris-trained theologian and it is therefore unsurprising that the new building, with its flat wall surface, slender proportions and large traceried windows, has been described by Christopher Wilson in his monograph on the architecture of the Gothic cathedral (1990) as 'England's only whole-hearted essay in [French] Rayonnant great church architecture' [28]. Rayonnant motifs had already appeared in the Chapter House vestibule, built by some of the same masons who now worked in the nave. In the nave, however, all decorative anomalies have been resolved and the Rayonnant elevation has been fully understood; the clerestory passage is pushed outside, making the clerestory windows flush with the wall. Their mullions are continued down to the triforium storey below, linking all the elements of the wall in an elegant and lofty composition.

This enormous space is given coherence by the use of two main tracery designs, one for the aisle windows and the other for the clerestory. This is a space flooded with light from all sides, its western vista dominated by another enormous, cliff-like expanse of glass standing in marked contrast to what must, at the time, have been a relatively far darker view to the east. The nave was structurally complete by 1339, when Archbishop Melton paid to have the curvilinear west window filled with stained glass, although the nave vault and the western towers were not completed for some years to come. The provision for a stone vault was made in the form of the bases of flying buttresses. In the event, the enormous width of the nave prompted a change of heart (or loss of nerve!). The vault was installed only in the 1350s, in wood painted to resemble stone, another feat of English medieval carpentry, leaving the flying buttresses unnecessary and unbuilt (those we see today were added only in the nineteenth century).

The medieval nave was the location of numerous altars and scores of monuments, the majority of them at the east end of the nave close to the tomb-shrine of St William,

28 Looking west: the design of the nave, begun in 1291, reveals a thorough familiarity with French architecture of the late thirteenth century.

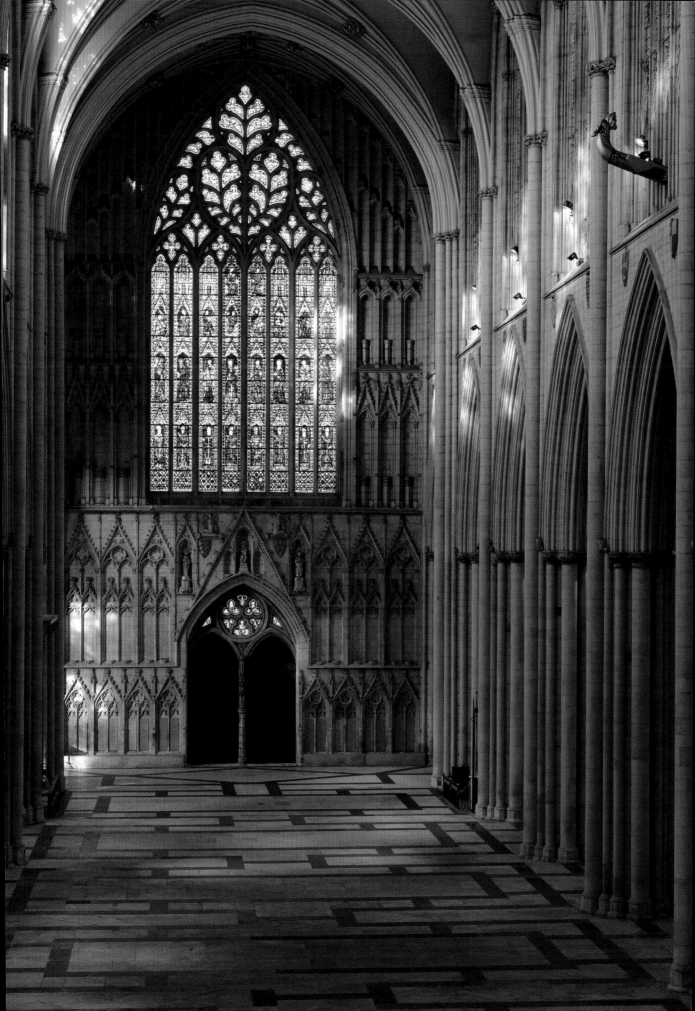

beautified and enlarged by Archbishop Melton in the 1330s. Indeed, the nave shrine was considerably larger than most of its contemporary rivals, only to be outshone by the new shrine constructed behind the high altar in the 1470s.

THE AISLE WINDOWS

Archbishop Romeyn did not live to see the nave completed. His successors, William Greenfield (1304–15) and William Melton (1316–40), were to be generous and enthusiastic promoters of the project. Greenfield made a number of gifts to the fabric and in 1306 encouraged others to do so by issuing an Indulgence worth 40 days' release from Purgatory for anyone who contributed. This Indulgence may well have been intended to attract donors for the glazing of the new nave, and Archbishop Greenfield certainly led by example, donating the first window on the south side (s29), where work had begun in 1291. It is easy to see why he should have chosen this location, for it placed his window close by the tomb-shrine of St William, who was both his predecessor as Archbishop and also shared his first name. Was William Greenfield placing himself under the protection of his canonised predecessor? Perhaps so, but in the subject of his window a devotion to another powerful and more established heavenly intercessor can be discerned, as the window depicts the life of St Nicholas, Bishop of Myra [29], to whom the Archbishop seems to have had a particular devotion. In 1315 he was buried beneath a splendid tomb in the chapel of St Nicholas in the north transept. As we shall see, Archbishop Greenfield was not alone in using his patronage of imagery as a means of maximising his spiritual well-being.

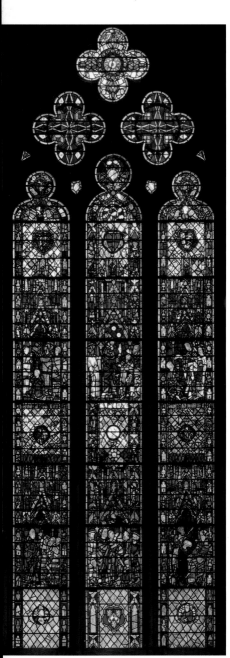

29 Archbishop Greenfield's window (s29) is dedicated to the life of St Nicholas of Myra. In 1315 the Archbishop was buried in St Nicholas's chapel.

Closely related to the window given by Archbishop Greenfield are the next two windows in the south aisle of the nave (s30 and s31). The identity of the donor of window s30 cannot now be identified with certainty and its subject matter has been confused by restoration and alteration. It may once have depicted the life of Christ. The next window (s31), dedicated to St John the Evangelist, was the gift of Chancellor Robert de Ripplingham (1297–1332), whose name was recorded by James Torre. Ripplingham is depicted at the bottom of the window as a teacher, reminding us that as Chancellor he was responsible for the cathedral school. The Chancellor was next in dignity to the Dean and it has been suggested that the preceding window (s30) may therefore have been the gift of Dean William de Hambleton (1298–1307) or perhaps Dean William Pickering (1310–12), both of whom might have been attracted to a location close to Saint William's tomb.

The fourth window on the south side (s32) was very heavily restored in 1903 by the London firm of Burlison & Grylls. It is nonetheless an outstanding window. The donor was Stephen de Mauley, Archdeacon of Cleveland until his death in 1317, who was also a member of one of the region's most prominent baronial families, the Mauleys of Mulgrave Castle near Whitby. The window depicts the martyrdom of Sts Stephen, Andrew and John the Baptist in its upper register, although it is probably the depiction of six members of the Mauley family that impresses us most [30]. Stephen de Mauley is accompanied by his father, Peter, Lord Mauley (d.1279) and his four brothers, Peter, Lord Mauley (d.1308), Sir Edmund, Steward of Edward II's household (d.1314), Sir John (d.1331) and Sir Robert (d.1331). Two of the saints above, Stephen and John, are the name-saints of the lords below. Each man holds aloft his shield of arms, reminding onlookers of the prestige of a family able to mount and equip several knights in the

service of the king. The Mauleys were probably the baronial family most prominently commemorated in the nave, as their arms also appear three times in the stone shields in the south nave arcade and six times in the clerestory windows above (S22, S23, S24), while Sir Robert was commemorated by a tomb with his effigy in full armour, which once stood to the west of the south-west crossing pier.

The easternmost window in the north aisle (n23) was also a clerical donation, the gift of Peter de Dene [32], Canon of York 1312–22 and Archbishop Greenfield's Chancellor and Vicar General. The window depicts the life and miracles of St Katharine [33], the patron saint of scholars and philosophers and therefore an appropriate choice for a master of arts and doctor of canon law. The window is also remarkable for its heraldic detail, with shields of arms set in grisaille and the tiny figures of knights and queens with heraldic tunics and gowns in the canopies and borders [31]. The heraldry reflects Peter de Dene's career in the royal service of Edward I and the young Edward II, where he rubbed shoulders with the highest in the land as a member of the prince's regency council. He came to York as a member of Archbishop Greenfield's household, although he did not secure a place in Chapter until 1312. He remained a Canon until 1322, when he was forced to leave the North because of his involvement in the uprising of Thomas of Lancaster. He retired to St Augustine's Abbey in Canterbury, where he had property within the monastic precinct and where he became a monk, although not a very good one, and probably died in 1334.

30 Window s32 celebrates the patronage of the baronial family of Archdeacon Stephen de Mauley (d.1317), who is represented with his father and four brothers. The window was heavily restored in 1903.

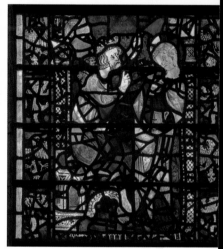

31 Kings of France and England from a canopy in the 'heraldic window'. Silver stain is used to highlight the white glass of the armoured figures.

32 A donor 'portrait' of Peter de Dene (n23), Canon of York 1312–22.

33 The main subject of the so-called 'heraldic window' is the life of St Katharine. Here she disputes with the Emperor Maxentius, who is counselled by a green demon perched on his shoulder.

Peter de Dene's window contains what is probably the earliest use in England of yellow stain, a technique that was to revolutionise stained glass. A liquid solution of silver nitrate or sulphide was applied to the exterior surface of white glass in those areas where yellow colour was required. When fired, a stain varying from pale yellow to deep amber was achieved. This technique could be used to colour hair, beards or small-scale decorative or architectural details without recourse to the laborious process of cutting and leading-in coloured inserts. It was less commonly used on blue glass to achieve green.

This precocious use of yellow stain makes the date of the window of considerable interest. The inclusion of what are believed to be the arms of the Knights Templar in the window suggests that it was made not long after Peter de Dene's arrival in York and perhaps in response to the Archbishop's 1306 Indulgence. Although the Order was not finally dissolved until 1312, in August 1308 the Pope issued three bulls accusing them of heresy and in 1309 he appointed Archbishop Greenfield to enquire into their alleged misdeeds. Greenfield convened a council, which met in York on 20 May 1310, perhaps assembled in the Chapter House. As the Archbishop's Vicar General, Peter de Dene must have been aware of the Order's imminent fate and is unlikely to have included a reference to them in his window once this was known.

Peter de Dene's window illustrates just how potent stained glass had become as a mode of commemoration. He is depicted at the base of his window as the epitome of a devout medieval churchman, asking for the onlooker to pray for his soul, an invitation expressed in Norman French, the vernacular of polite and educated society in the fourteenth century. The eminent Victorian stained glass scholar Charles Winston (1814–64) wrote an important article about his remarkable 'heraldic window', and we continue to celebrate its outstanding technical qualities. Only in more recent research by F. Donald Logan has the true and less admirable character of the man behind

the stained glass image begun to emerge. During a visitation of St Mary's Abbey in York he was described by the monks as 'a dreadful snake', while his later career as a Canterbury monk was characterised by luxurious living, disobedience, arrogance and an accusation of theft!

The glaziers responsible for the windows commissioned by senior members of the Minster clergy and destined for the south aisle of the nave (s29–s31), together with window n23, worked in very similar styles and may have belonged to a single workshop. In the windows of the north aisle other workshops can be identified. Window n24, to the west of Peter de Dene's heraldic window, is in marked contrast to it in both style and content. While the 'heraldic window' gives a glimpse of a cosmopolitan, courtly world and commemorates a saint of universal significance, Richard Tunnoc's window [34], with its scenes of bell-founding, offers insights into the preoccupations of a wealthy York craftsman and commemorates St William, whose shrine stood nearby and to whom Tunnoc offers an image of his window. Tunnoc was a goldsmith and bell-founder, bailiff of the city 1320–1 and MP in 1327. He lived in nearby Stonegate. In the bell embroidered on his purse, in the large numbers of bells that adorn the borders of the window and in the design of the canopies over the scenes, which resemble the bell-frame of a carillon, Tunnoc was celebrating the profession from which he derived his wealth, using a bell as a badge every bit as recognisable as the heraldic devices employed on the coats of arms displayed by the baronial families commemorated all around him. Bells dominated the soundscape of

34 Richard Tunnoc (d.1330), goldsmith, bell-founder, bailiff and MP for the city, commemorated with St William and images of his own profession (n24).

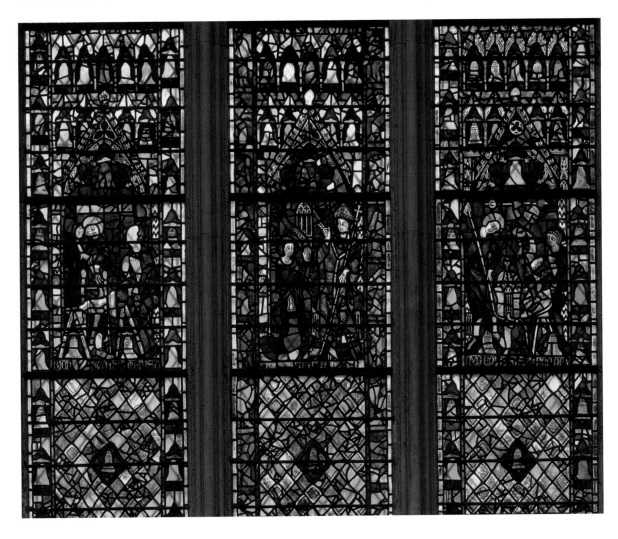

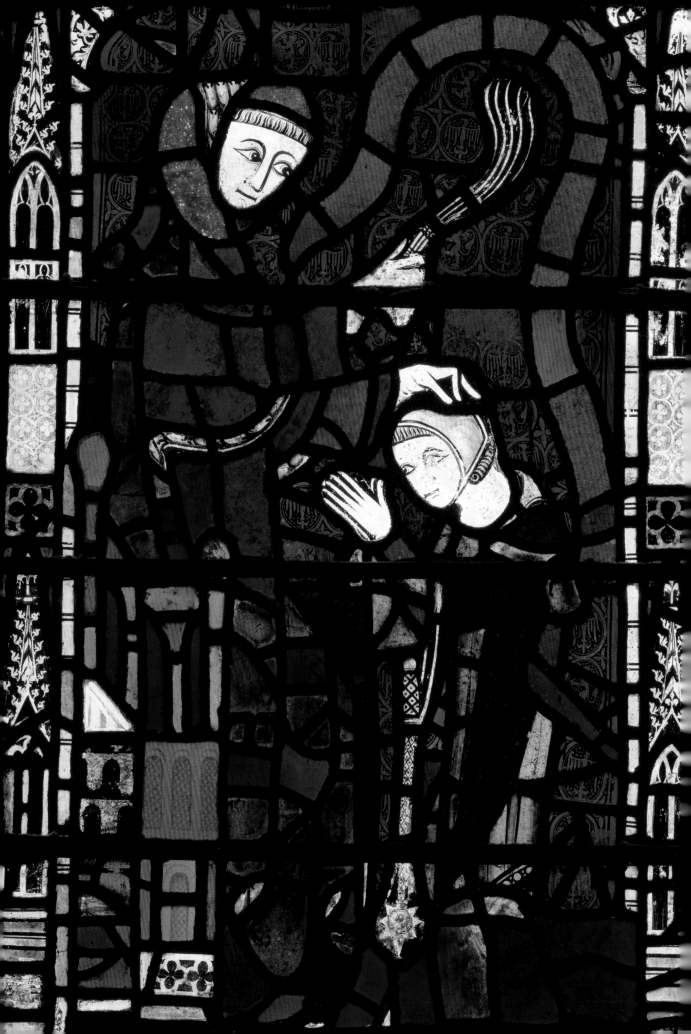

the medieval city, helping its citizens to keep time, signalling Minster services and, while the 'sacring bell' pealed during the mass, heralding the moment at which the host was elevated, consecrated and miraculously transformed into the body of Christ. In 1328 Tunnoc founded a chantry at the nearby altar of St Thomas Becket, thereby ensuring that he enjoyed the protection of a second powerful heavenly intercessor. He was one of only three private citizens to found a chantry in the medieval Minster and, unusually, chose to be buried there in 1330 rather than in his parish church.

By the same glaziers as the Tunnoc window is the one depicting the activities of the Penancers (n27), the Minster priests appointed by the Archbishop to hear the confessions of the Chapter and those of such eminence that they did not wish to confess to their parish clergy. In 1308 William Langtoft was appointed to the post and in 1311 he was specifically entrusted with the task of hearing the confessions of the Templars, who, thanks to Greenfield's moderation, escaped the torture and death that was commonly their fate elsewhere in Europe. Langtoft was also one of the Keepers of the Fabric, and in 1311 Greenfield entrusted 100 marks to his custody. The upper register of scenes depict the martyrdom of St Peter, to whom the Minster is dedicated [back cover], while the main scenes in the lower register of the window depict the Penancers at their penancing [35]. The borders show tonsured clerics holding keys and pouring coins into coffers, and masons hewing stone, apparently reflecting the various aspects of Langtoft's career. In the early years of the twentieth century J.W. Knowles recorded what seems to have been part of Langtoft's name under one of the penance scenes. In 1317 Langtoft also founded a chantry at the altar of St Thomas Becket and was buried there in 1321. A shared devotion to St Thomas and an interest in his Minster altar may have brought Tunnoc and Langtoft into contact with one another and may account for the fact that their windows were made by the same glaziers.

The remaining two windows in the north aisle containing substantially original glazing are also of considerable interest. The so-called Pilgrimage window (n25 [36])

Opposite

35 A Penancer of the Minster (n27). The window was probably the gift of William Langtoft, who was appointed in 1308 and died in 1321.

36 The Pilgrimage window (n25), in which two wealthy lay people approach an enthroned figure of Minster patron St Peter.

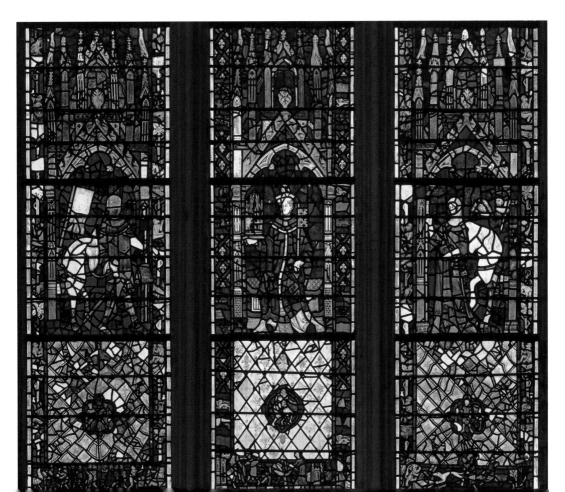

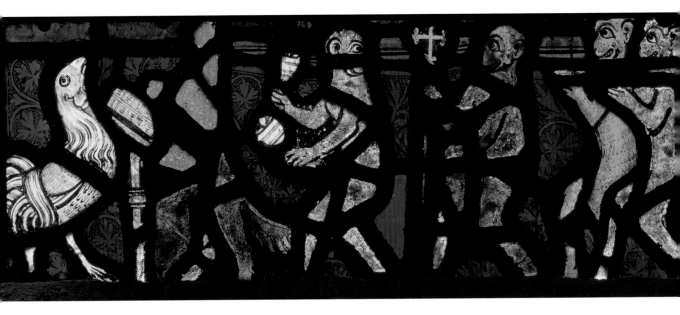

depicts the Crucifixion in its upper panels, while in its lower register is a large image of St Peter, flanked by a male and female pilgrim with horses and attendants, suggesting that they were people of some substance. It is the borders of the window that have attracted the greatest interest. The vertical borders contain squirrels and monkeys with urine flasks, a parody of the medical profession, while along the base of the window [37] is Reynard the fox preaching to a cock, a parody of the funeral of the Virgin Mary enacted by monkeys, a monkey doctor examining a patient, a parody of a hunt, and the famous scene of Reynard stealing a goose. These amusing and somewhat subversive scenes can be compared to the borders of the pages of illuminated manuscripts of the period. While scholars continue to debate their significance and meaning, it is highly unlikely that the artists who created these marginal images, paralleled in some of the nave aisle sculptures, were simply given a free hand in the decoration of extremely expensive and public works of art displayed in the mother church of the Northern Province, so we must presume that these playful 'drolleries' echo the taste of their patrons.

Immediately west is the Martyrdom window (n26), so-called for the depictions of the martyrdoms of St Lawrence, St Denis and St Vincent in its upper register, of St Edmund and St Stephen in the small medallions in the grisaille panels, and of St Peter and St Paul in the tracery above. A donor figure in the lower register is accompanied by an inscription (in French) requesting prayers for Vincent, whose name-saint appears above [38]. Two other unidentified donor figures appear in the third light. The borders of the window are filled with the alternating arms of Mowbray (*gules a lion rampant argent*) and Clare (*or three chevrons gules*) and seem, therefore, to refer to John, second Lord Mowbray, the son of Roger (III) de Mowbray and Rose de Clare, sister of Gilbert, the last Clare Earl of Gloucester (d.1314). John was active in the Scottish campaigns of Edward II's reign and in 1312 was made Keeper of the City of York and of the county and is know to have been in York when Parliament met there in 1318. His arms also appear in glass in clerestory window N21 and in stone in the seventh bay of the south nave arcade. The window is likely to date from before March 1322, when John was executed for treason after fighting with Thomas of Lancaster at the battle of Boroughbridge. His body remained on display in York for three years and only after the accession of Edward III was it to find burial in the Dominican church in the city. It may be John and his wife Aline (de Braose), who appear in the window with Vincent, whose identity sadly remains a mystery.

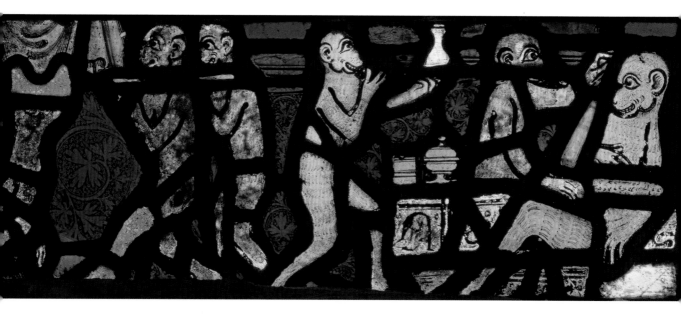

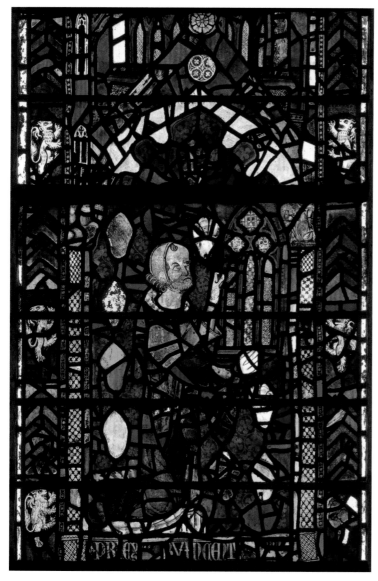

38 The 'donor portrait' of layman Vincent in the Martyrdom Window (n26). The heraldry of the Mowbray and Clare families decorate the borders.

THE HERALDRY

While the reconstruction of the nave was initiated and supported by the Archbishop and the Chapter, the project undoubtedly benefited from the transformation of York into the second city of the realm by the presence of the Exchequer and the military administration for long periods between 1298 and 1338. The nave arcade is decorated with a series of great stone shields commemorating the King and members of the nobility in a display that resembles both that in the nave aisles of Henry III's Westminster Abbey and the armorial rolls that recorded those who gathered together for parliaments, councils, tournaments and military campaigns. The sequence of stone shields commences with the arms of Edward I and his brother, Edmund, Earl of Lancaster, which are carved in the spandrels of the first bay of the south nave arcade [39]. The King had assisted at the translation of the relics of St William in 1284 and was a beneficiary of his miraculous healing. He made offerings at the shrine in 1300 and it is possible that he had contributed to the costs of the work. A similar heraldic display is found in glass in the clerestory windows. In each of these the arms of the King are flanked by four shields of arms of noble families who owed him military and political service [40]. The shields may also be indicative of contributions to the fabric fund, and it must have been comforting to know that as one headed off for battle, one remained in the sight and in the prayers of the cathedral community of York. Bishop

39 The arms of King Edward I and his brother, Edmund 'Crouchback', Earl of Lancaster appear in stone in the first bay of the south nave arcade.

Opposite
40 A nave clerestory window (N21) in which the arms of the King are flanked by those of his loyal northern nobility.

Anthony Bek, whose arms appear in the window N21 and in the second bay of the south arcade, had funded the translation of St William's relics. The Percy and Vavasour families, whose arms appear in stone in the seventh and eighth bays of the arcade, were both donors of building materials. In 1313 Peter de Mauley (d.1348), whose family arms are well represented in the nave, was required to pay a fine of 100 marks to the fabric fund as punishment for adultery. It must be assumed that other contributions were of a more voluntary nature!

Although the nave heraldry does not allow precise bay-by-bay dating, closer scrutiny of the careers of individual knights and barons represented in the nave in glass and stone suggests that one period above all was auspicious for donations. Nearly all were prominent in the prosecution of Edward I's Scottish campaigns of 1298–1307 and a large number of the shields in the nave are also found in the Falkirk Roll recording those involved in the triumphant Falkirk campaign of 1298. Most of the nobles represented were called upon to serve in person, as landowners in the North and Scottish marches, and a number were to be severely impoverished as a result of Edward II's failure to maintain the status quo after his father's death. Many continued to serve until political dissatisfaction boiled over into rebellion in the 1320s. Some of the individuals commemorated were long-lived and could have contributed to the fabric fund at any time over a long period. Sir Ralph Bulmer, for example, whose arms appear in glass in window N24 and in stone in bay 5 of the north nave arcade, succeeded to his estates in 1299 and lived until 1356. Sir Henry Fitzhugh (S27), who succeeded his father in 1305, also died in 1356. On the other hand, three of those commemorated in the nave died at the calamitous battle of Bannockburn in 1314: Gilbert de Clare, the last Earl of Gloucester (bay 2 of the south nave arcade and window S22), Sir Robert de Clifford (S25) and Sir John Mauley (S23 and nave aisle window s32). Two of those represented (Sir John Mowbray, N21 and the seventh bay of the south nave arcade, and Sir Robert Ryther in S27) were companions of Thomas of Lancaster executed for treason after the battle of Boroughbridge in 1322, while others represented were discredited adherents of Thomas of Lancaster who escaped death but were impoverished and disgraced.

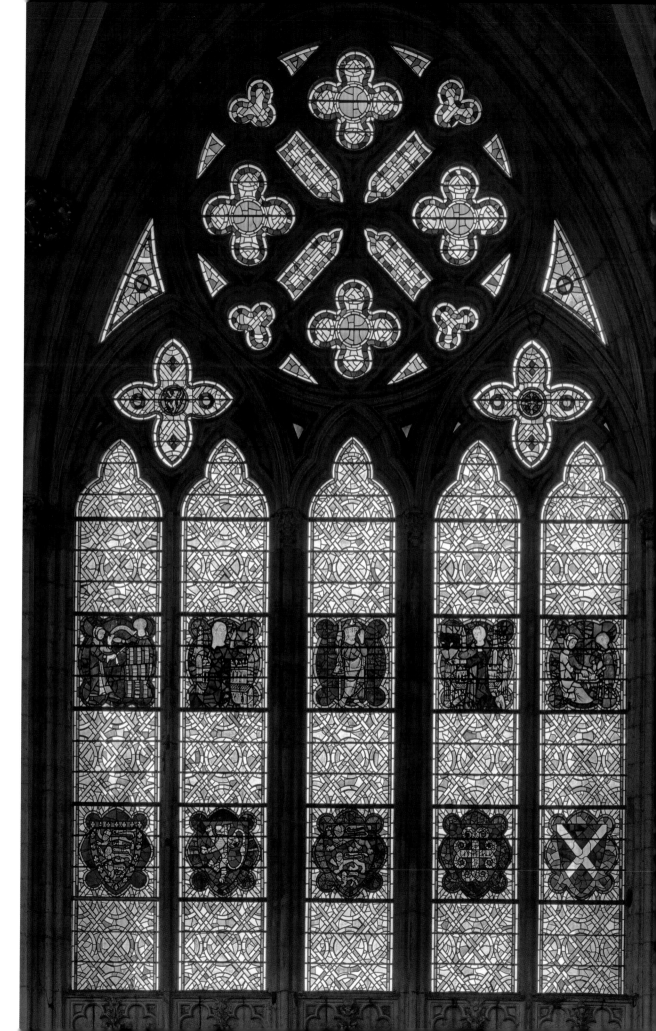

Many of these men were also bound together by ties of fealty and family, the latter most commonly represented by intermarriage. Sir Ralph Bulmer and Sir Nicholas de Meynill, for example, held lands of Peter de Mauley, while Bulmer also held land of Ralph de Neville. Sir William de Ryther married the daughter of Robert, Lord Ros of Helmsley. Sir Peter de Mauley (IV) married a daughter of Sir Thomas Furnival and committed adultery with her sister. Sir Ralph Bulmer and Sir Henry FitzHugh were brothers-in-law and Sir Ralph married Sir Walter de Fauconberg's widow. Walter de Fauconberg's son, also Walter, had married a daughter of Sir Robert de Ros of Helmsley but predeceased his father, another casualty of Bannockburn. The nave is thus a microcosm of a relatively small and close-knit aristocratic society.

There is also a sense in which the Minster's nave presents a complex image in glass and stone of a perfect society of knightly amity and loyalty, led by the King and blessed by the Church. A similar image had been perpetuated in the earlier nave of Westminster Abbey. The later years of Edward I's reign were marred by friction between sovereign and nobility, tensions that greatly worsened after 1307, during the reign of his politically inept son. Success against the Scots in the opening decade of the fourteenth century perhaps camouflaged these social and political fissures, but the disaster at Bannockburn heralded a period of violence and unrest in the North which had a serious impact on the material prosperity of the Northern Province. Dissatisfaction with the King and his rapacious favourites finally erupted into open rebellion. Thomas of Lancaster was executed in Pontefract and, as we have seen, a number of his supporters, some of whom had contributed to the Minster's fabric fund (including John Mowbray), were publicly hung, drawn and quartered in York. Thus by the time the nave was approaching completion, the concept manifested in its heraldic displays would have seemed increasingly at odds with reality.

THE CLERESTORY

The balance of alternating light and dark bands of glass established in the nave aisles is maintained at clerestory level, although in only one window (N25) are simple canopies preferred to the earlier type of medallion frame. Light streams in to the upper levels of the nave through the reused panels of eleventh- or twelfth-century unpainted geometric grisaille, salvaged from the demolished nave and extended and adapted to receive two registers of coloured glass. The lower coloured register in each window was filled with the shields of arms discussed above. The upper register was filled with a mixture of reused twelfth-century figurative glass and newly made figure panels. The twelfth-century glass has been discussed fully above, but the nature of its reuse sheds valuable light on the progress of the fourteenth-century work in the nave.

The original location in the nave clerestory of the reused twelfth-century panels has been affected by nineteenth-century restoration and the introduction into the two easternmost windows on north and south sides (N19, N20, S21 and S22) of the 1844 Barnett copies of the Chapter House east window, which served to push a number of panels westwards. It is clear, nonetheless, that the predominance of reused glass was originally on the south side of the nave, supporting other evidence that the south side of the building proceeded ahead of the north. Only the first two eastern bays of the northern clerestory were originally glazed in this way and, as these bays are the ones that buttress the central tower, their rapid completion was a necessity.

While salvaged twelfth-century glass (and some sculpture) was undoubtedly preserved as a souvenir of an earlier venerable structure, a measure of financial expediency probably also played its part. Both glass and stone were reused predominantly on the south side of the nave, the elevation facing the city, which required early completion and at high levels, where their antiquity would have been

less evident. In order to complete the decoration of the upper levels of the southern elevation quickly, allowing scaffolding to be struck, the Chapter seems to have dipped into its own stores for suitable material. Twelfth-century stained glass was adapted for reuse in the southern clerestory windows, while Romanesque sculpture was used to fill the niches of its external pinnacles. As we have seen at aisle level, where windows are far more legible and consequently far more appealing to patrons, prominent members of Chapter had led by example in providing the first of the new windows on the south side.

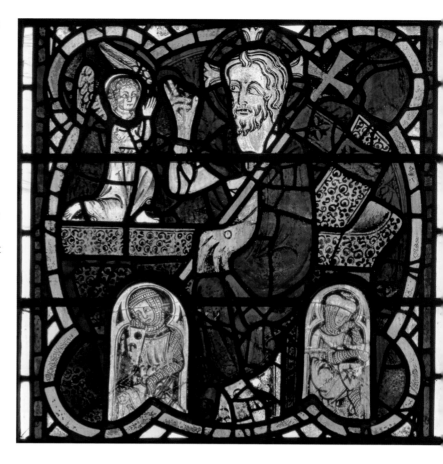

41 The Resurrection of Christ in N23.

In the glazing of the north nave clerestory, the Chapter was apparently more successful in attracting donors. The relationship between the workshops employed at aisle level and those who made the new clerestory windows has not been fully investigated. At first glance the unsophisticated, almost naive figure style of the clerestory windows, with short, broadly proportioned figures with large heads and hands, simply painted, without yellow stain and on glass with a limited colour range, might prompt the conclusion that the clerestory windows are much earlier in date than the more consciously elegant aisle windows. The donor of window N24 can be identified as Robert Wainfleet, Abbot of Bardney (1280–1318). The circumstances of his turbulent career, much of which was spent deprived of his temporalities, suggest a date of c.1310–12 for his gift, when he was temporarily restored to his abbey prior to the disputes that finally led to his resignation. It is clear, therefore, that subjective stylistic observations must be treated with caution, as the relatively unsophisticated style of the clerestory windows can also be interpreted as a response to their location, with some foreshortening and exaggeration of the figures and a strong palette of colours making them more legible from the ground. The restricted palette and absence of yellow stain were perhaps also in response to the twelfth-century glass that the glaziers were installing in adjoining windows, and the predominant use of geometric frames rather than architectural canopies ensures that the figured panels balance the heraldic display in the lower register.

As in the aisles below, the diversity and some repetition of subject matter suggests that while the Dean and Chapter were able to insist upon a consistency of design and general layout, the subject matter of the clerestory windows was to some extent influenced by the preferences of the donor. Abbot Wainfleet chose clerical saints for window N24: St Peter, St Edmund, two archbishops (St William and St Wilfrid?) and a bishop blessing a king (Aidan with St Oswald, some of whose relics were held at Bardney?). The unidentified donor of N23 chose subjects that together represent the joys of the Virgin Mary: the Annunciation, Nativity, Resurrection [41], Ascension and Coronation. In N21 [40] are figures of St James the Great and a kneeling male

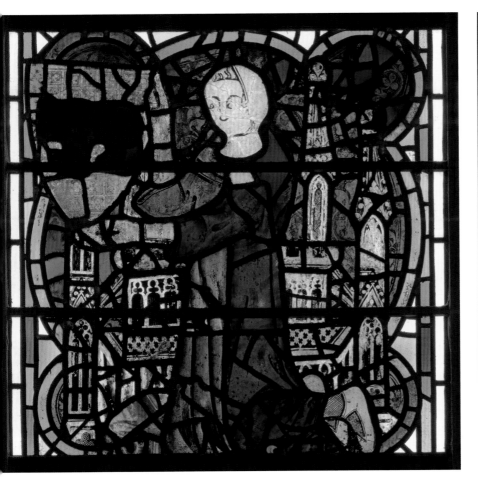

42 An unidentified male pilgrim kneeling before a figure of St James (N21).

43, 44 Two scenes apparently depicting the commerce of a wine merchant (N21). Trade scenes in English stained glass are rare.

and female donor [frontispiece] dressed as pilgrims at a shrine. St James's shrine at Compostela was the most popular pilgrimage destination in the Middle Ages. Sir Robert Fitzwalter, for example, whose arms appear in N22, went on three pilgrimages, including one to Compostela in 1280, and in 1361 Agnes de Holme left a sum of money equivalent to the cost of one man going to Compostela for the making of a window in honour of St James. The shield held by the male pilgrim [42] now shows a bear and led Dean Milner-White to identify the figure as Minster Treasurer Francis Orsini (FitzUrse) and his wife! Orsini would not have been shown in secular dress, nor would he have acknowledged a wife, so this cannot be correct. In c.1690 Torre described the shield in question as 'or a lion passant murrey [purple]', similar to the arms of Edward I's military commander in Scotland, Henry de Lacy, Earl of Lincoln (1249–1311), whose arms were *or a lion rampant purple* and who had visited Spain on a royal embassy in 1291. However, as the kneeling pilgrim is not dressed as a soldier it seems unlikely that Earl Henry is depicted here.

Of particular interest are two scenes also now in window N21, depicting the activities of a wine merchant [43, 44]. Together with Tunnoc's bell-founding scenes (n24), these are the only images of York's commercial life depicted in the nave windows. Images of trades and occupations are rare in English stained glass. The closest parallel to the York window is in a thirteenth-century window dedicated to St Lubin in Chartres Cathedral, which was apparently given by the wine merchants of that city. It is impossible to tell whether these York panels mark the generosity of an individual merchant or a 'corporate' donation. Like the bells in Tunnoc's window, wine, of course, also has a liturgical significance. There are no later images of

doctors?
in margins
of Pilgrim
window

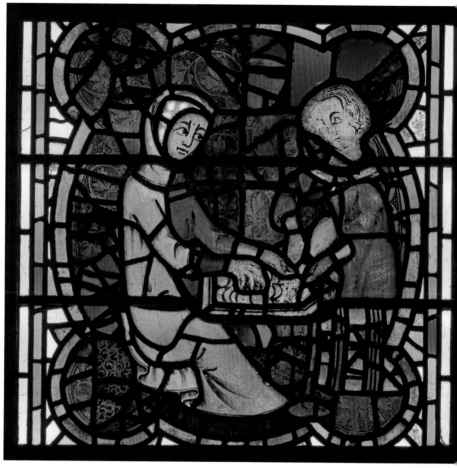

trade or commerce in the Minster's windows, perhaps because by the end of
the fourteenth century the performance of the Corpus Christi play cycle provided
an alternative outlet for trade guild munificence.

THE WEST WALL

The westward vista of the nave is dominated by the curvilinear grace of the west window
[28], which in both scale and design marks a departure from the treatment of the other
nave windows. Although the tracery design of the west windows of the two aisles (n30
and s36) is the same as that of the rest of the nave aisles, the stained glass of these two
windows links them to the west window glazing campaign. Examination of the masonry
of the west wall reveals that while the aisles, including the tracery of windows n30 and
s36, and lower stage of the wall belongs to the first nave campaign, the upper stages of
the west wall, including the tracery of the west window, were constructed in a later and
stylistically separate phase. The break between one building campaign and another can
be discerned most clearly at the level of the fourth tier of arcading, where nodding ogee
arches are introduced into the canopy heads. The most dramatic expression of this new
phase of work is the tracery of the west window itself [45].

This new departure can confidently be attributed to the encouragement and
personal generosity of Archbishop William Melton (1316–40). At some time in the
1330s Melton gave £20 for the making of a new tomb-shrine of St William at the east
end of the nave, making it one of the largest shrine structures of its day. On 7 June
1338 he made a gift of 500 marks to the fabric fund and on 4 February 1339 gave a
further 100 marks for the glazing of the west window, described as 'newly constructed'.

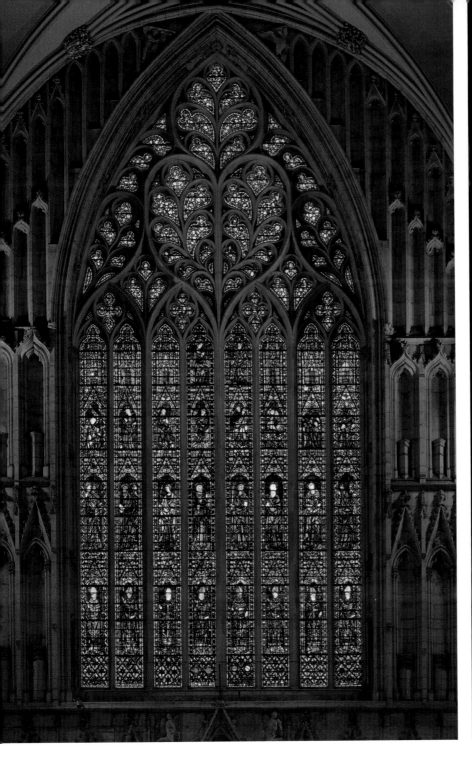

45 The west window. The tracery of the window was probably installed in the building season of 1338. The stained glass was commissioned on behalf of Archbishop Melton in February 1339.

The original contracts for the west windows do not survive, although Torre read and summarised them in both Latin and English. Melton entrusted his 100 marks to the Keepers of the Fabric, Thomas Sampson and Thomas Ludham; it was Thomas Ludham who, four days later, signed the contracts with the glaziers commissioned to make the west windows. The glazier Robert (perhaps Robert Ketelbarn, made a Freeman of the City in 1324) was to make the west window, while a second glazier, named Thomas Bouesdun, was to glaze n30 and s36, ordered at the same time although under separate contract. The aisle windows once contained donor figures, although these have been lost, replaced by figures made by William Peckitt in 1758.

Torre's transcriptions reveal that the two contracts were framed rather differently. Thomas Bouesdun was paid 11 marks for each window, while Robert was to receive

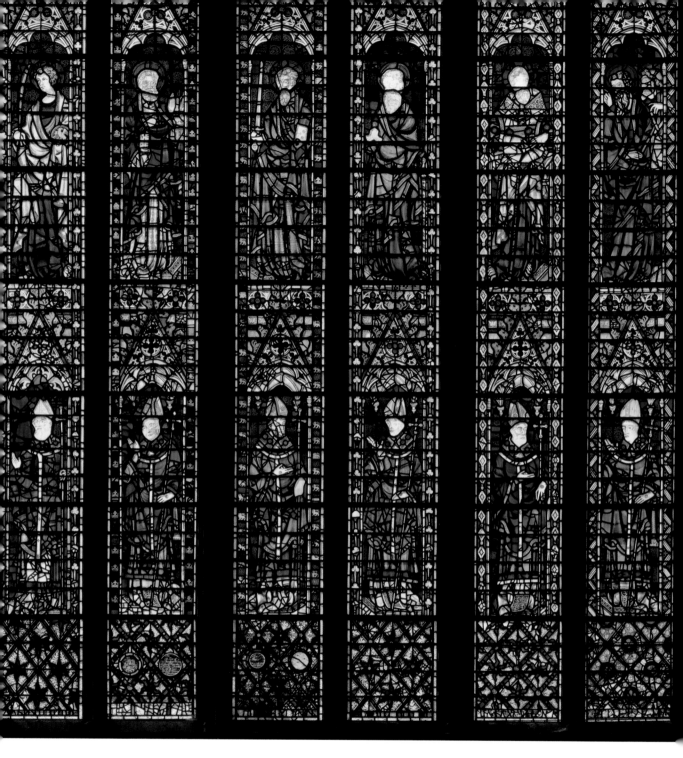

6d per foot for white glass and 12d per foot for coloured. The windows are all characterised by the excellent quality of their exceptionally well-preserved glass. Designing, cartooning, painting and glazing are not mentioned separately, although the reference to Melton's donation gives us the overall cost of the window. Nor do the contracts mention the subject matter of the windows, which must have been specified in separate documents, probably in the form of a certified sketch design (called a vidimus).

Even without the documentary evidence of Archbishop Melton's register, his involvement might have been guessed, for in the lowest tier of figures, eight of his predecessors are depicted [46]. In the late seventeenth century Torre was able to distinguish six of the eight inscriptions identifying St John of Beverley (705–18), Thomas of Bayeux (1070–1100), St Wilfrid (669–77), St Oswald 972–92), St William

46 The first two tiers of figures in the west window depict the illustrious bishops and archbishops of the See of York, made from only three cartoons, paired with the biblical apostles.

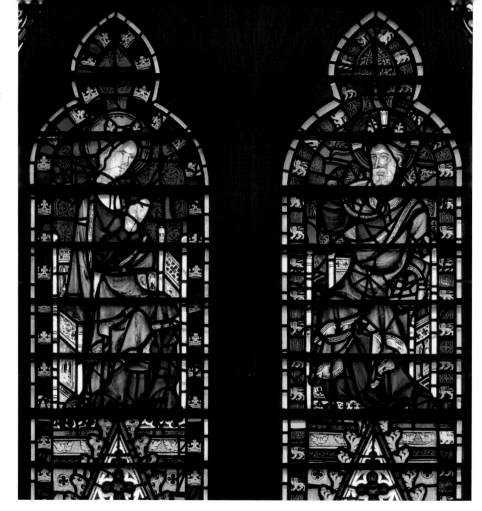

(1143–7 and 1153–4) and Sewal de Bovill (1256–8). St Paulinus, St Chad, St Wilfrid II, St Bosa and St Egbert would all be candidates for the remaining two unidentified figures. The inclusion of Thomas of Bayeux, who was not a saint, nor even, like Sewal de Bovill, locally revered as one, is interesting, for it suggests that Melton was anxious to be identified with another great benefactor and builder of the nave. Indeed, the late fourteenth-century historical tables of the vicars choral commemorated him in this capacity. The window is Melton's luminous statement about the history and prestige of the Northern Province and its great cathedral church. The archbishops are thus represented as the apostles of the North, while the 12 biblical apostles [48], somewhat awkwardly squashed into eight lights, stand immediately above the episcopal figures. St Paul, so often paired with St Peter in York Minster, has been included at the expense of St Matthias, the apostle who replaced Judas Iscariot. The third and fourth tiers contain narrative episodes spread across two lights, depicting five of the Joys of the Virgin Mary – the Annunciation, the Nativity, the Resurrection, the Ascension and the Coronation of the Virgin [47]. With the exception of the medallions of the Pelican in her Piety and the Agnus Dei, the tracery is filled with decorative foliage.

While the west window is far richer in palette and decorative repertoire than the earlier nave windows, it nonetheless maintains the pattern of balanced horizontal zones of light and dark established in the earlier glazing programmes. The west windows of the north and south aisles depict the Virgin and Child with virgin martyrs St Katharine and St Margaret (s36), and the Crucifixion with the Virgin and St John the Evangelist (n30). All three windows were restored in 1757–8 by William Peckitt, who supplied new heads for a number of the figures, which in terms of technique and style are somewhat incongruous but represented a sympathetic attempt to preserve the legibility of the windows.

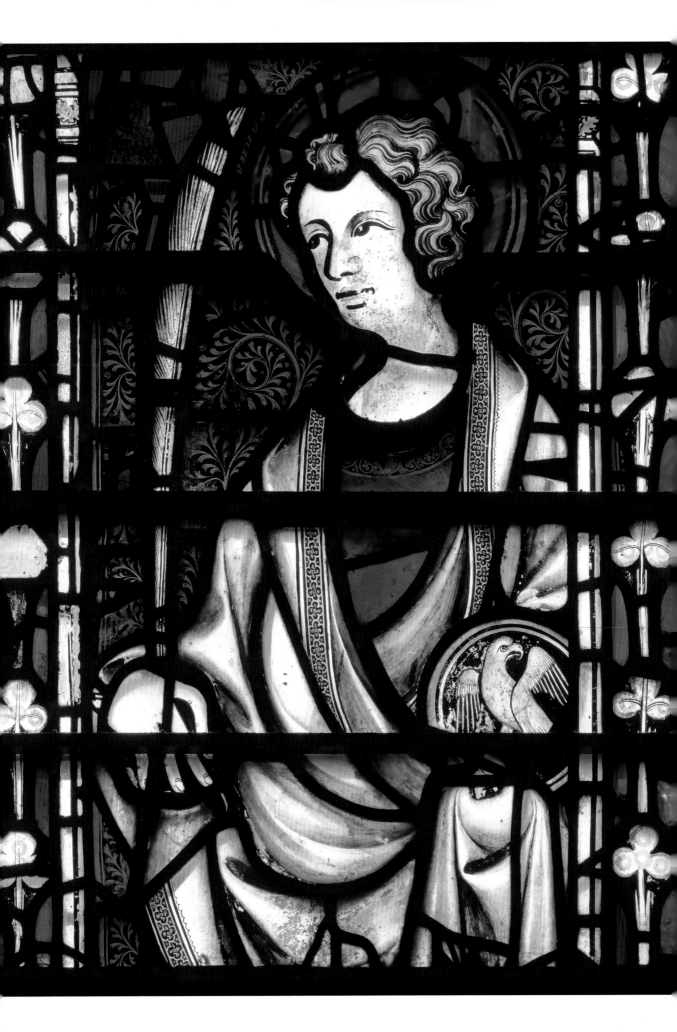

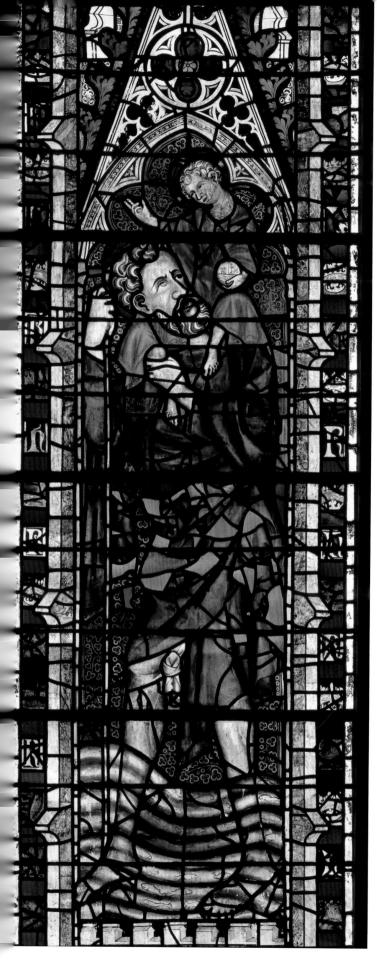

Left
49 St Christopher (*c.*1340), now located in n4 but probably made for a window at the west end of one of the nave aisles.

50 Sts Matthew (or Simon?), Paul, John the Evangelist, Andrew and Bartholomew (holding his own flayed skin!), stand below small scenes of the Adoration of the Magi, Massacre of the Innocents, Presentation in the Temple, Flight into Egypt and the Annunciation of the Virgin's Death. The glass was made *c.*1340 but was reused *c.*1370 in the clerestory of the new Lady Chapel (S3).

Below
51 The Massacre of the Innocents, *c.*1340 (S3).

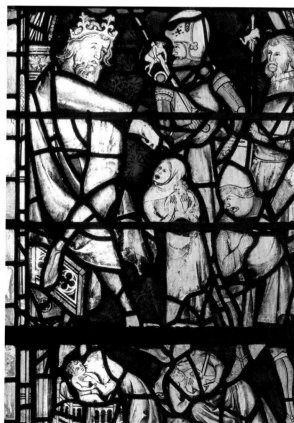

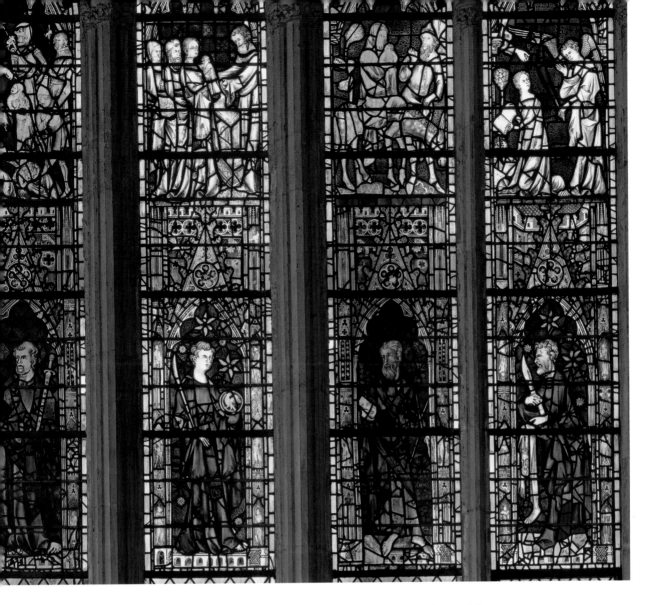

The size of the workshops headed by Master Robert and Thomas Bouesdun and the exact relationship between them is unknown, but the three windows are characterised by a remarkable consistency of quality and style and are stylistically, to all intents and purposes, indistinguishable from one another. A considerable quantity of other glass in the Minster and the city parish churches seems to be by these or very closely related workshops. In the Minster this glass is now mostly to be found in the choir.

Large figures of Saints Stephen, Christopher [49] and Lawrence now in the Lady Chapel aisle (n4) may have been made for the western windows of the nave aisles, while in windows n2, n5, s2, S3 and S4 are smaller-scale figures and narrative panels of unknown provenance, reused in the Lady Chapel in the late fourteenth century [50, 51]. Panels from this collection depicting the Annunciation and Joachim in the wilderness have been inserted in nave aisle window s35. The narrative panels have a strongly Marian significance and they may have come from the chapel of St Mary and All Angels to the north of the nave. Recently, however, it has been suggested that the parish church of St Mary ad Valvas, a property of the Dean and Chapter situated to the east of the Lady Chapel, demolished in 1364 to make way for the new east end, may have been their original home.

The west windows and the stylistically related panels scattered around the Minster provide valuable evidence of the transformation of English glass painting in the second quarter of the fourteenth century. This was a style shift also happening elsewhere,

52 The Annunciation, c.1340, presented within a 'doll's house' architectural environment (s35).

Opposite
53 The Annunciation of the Virgin's Death, c.1340, in a heavily modelled, almost 'grisaille' technique, reminiscent of Pucellian manuscript illumination. The panel was reused c.1370 in the Lady Chapel clerestory (S3).

including in London, but poor survival rates make York the best place to study it. The glass suggests a familiarity, albeit sometimes misunderstood, with new pictorial formulae and iconographic features derived ultimately from Italian Trecento art. The kneeling angel Gabriel in the Annunciation (in the west window and in the panel now in window s35) and the grieving angels flying around the Crucified Christ in window s36, for example, have their origins in Italian wall and panel paintings of the early fourteenth century. While direct contact with portable works of art imported from Italy cannot be completely discounted, exposure to an alternative source of Italianate influence, namely Parisian art of the first quarter of the century, is more plausible. In works such as the Hours of Jeanne d'Evreux and the Belleville Breviary, the Parisian miniaturist Jean Pucelle had assimilated Italian iconographic innovations and spatial experimentation with Parisian refinement and delicacy. A comparison of the 'doll's-house' interior of the Annunciation in s35 [52] with the equivalent scene in the Hours of Jeanne d'Evreux reveals the relationship between the art of Master Robert and his circle and that of Jean Pucelle and his followers, although it is also a comparison that reveals that the York glass painter has imperfectly understood his model; the York glass panel is full of spatial inconsistencies. The preference for an essentially monochrome effect, with figures silhouetted against coloured backgrounds, enlivened only with yellow stain, is a further indication of an indebtedness to 'Pucellian' art [53].

In England it was episcopal patrons such as Archbishop William Melton of York, Bishop Grandison of Exeter and Bishop Richard de Bury of Durham, all of whom had travelled widely in careers in service to the King, who sponsored the artists responsible for introducing these new styles into England.

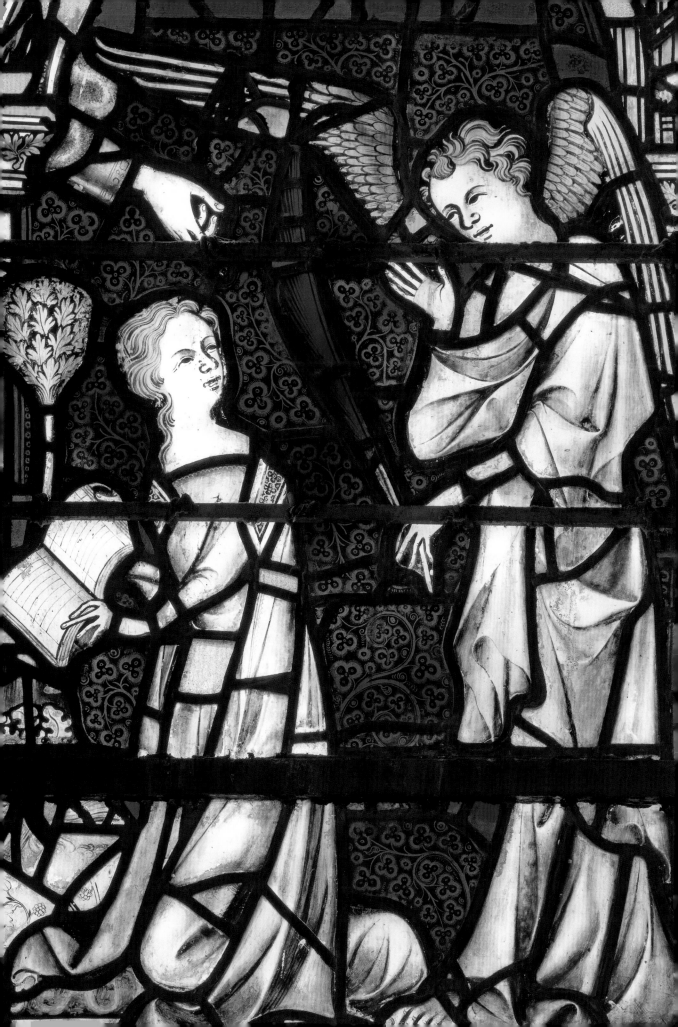

THE GLAZING OF
THE EASTERN ARM

THE REPLACEMENT of the cathedral's twelfth-century eastern arm was achieved in two phases. The Lady Chapel was constructed in the period 1361–c.1373 and the western choir was rebuilt between c.1394 and c.1420. Despite Archbishop Melton's generosity, the nave had remained incomplete at his death in 1340. The nave vault had not yet been installed and the roof lacked a lead covering, so that in 1345 puddles of water were reported to be gathering on the pavement. Nonetheless, by 1348 the Chapter was beginning to contemplate the construction of a new choir, for in that year Canon Thomas Sampson bequeathed £20 to the fabric, as long as work began within one year.

The arrival in York of the plague known as the Black Death in the summer of 1349 offers the most likely explanation for the disruption of these plans. Two-fifths of the beneficed clergy of the diocese died and it is likely that craftsmen were as badly affected as their patrons. There were to be further outbreaks in 1361–2, 1369 and 1375. Throughout England architectural projects were interrupted or curtailed and stained glass production was sharply reduced. In London, for example, King Edward III was forced to summon glaziers from 27 counties in order to assemble a sufficiently large workforce to undertake the glazing of St Stephen's Chapel in the Palace of Westminster (1351–2). In York the free-standing chantry chapel to the east of the south transept planned by Archbishop Zouche (1340–52), for which generous funds were made available, remained unfinished at the time of his death, and he was buried in the nave.

Zouche's successor, Archbishop John Thoresby (1352–73), therefore inherited a cathedral church with an incomplete and leaking nave and with unfulfilled ambitions to replace its twelfth-century choir. Thoresby was an energetic administrator, reformer and educator, and a former Chancellor of England, indebted to William Melton for advancement early in his career. He first turned his attention to the completion of the nave, in 1353 issuing an Indulgence to those giving to the fabric and in 1355 supplying the timber that enabled the master carpenter, Philip of Lincoln, to complete the nave vault soon afterwards. For probably no more than a few years the Minster functioned without the distractions of builders, scaffolding and partially constructed walls. With the nave finally complete, albeit with its western towers unfinished, attention soon turned east once more.

THE LADY CHAPEL

On 30 July 1361 the foundation stone of a four-bay eastern extension to the cathedral was laid out to the east of Archbishop Roger's choir. In his submission to the Pope, Thoresby explained his reasons for requiring the new building. The first reason was liturgical: the Minster lacked a seemly place in which to celebrate the daily mass of the

54 The head of King Edward the Confessor at the base of the Great East Window. Possibly the autograph hand of John Thornton.

55 Archbishop Thoresby's new Lady Chapel extension provided the Minster with yet another cliff-like façade in which stained glass could be displayed to great effect. The Lady Chapel was completed by 1373, but the east window was not to be glazed until 1405–8.

Virgin Mary, at that time observed at an altar in the crypt. The other arguments touch upon aesthetic matters: the old choir was too 'homely' and compared unfavourably to the magnificence of the newly completed nave. Furthermore, it was fitting that the church be adorned throughout with a uniform beauty and becoming craftsmanship. Thoresby was prepared to back this up financially. Over the next 12 years he was to pay £200 per year into the fabric fund and offered spiritual inducements to those who also contributed. The market for Indulgences was so valuable that steps had to be taken to suppress forgeries.

With this steady stream of money the building progressed rapidly. By 1364 the chantries and altars at the eastern end of Archbishop Roger's choir were suspended, a prelude to the demolition of the east wall of the old choir. A temporary wall must have been erected on the eastern side of the choir transepts to protect the Minster from the noise, dust and disruption of work on the new structure. By the time Thoresby died, on 6 November 1373, the four-bay extension was sufficiently complete to receive his burial before the new Lady Chapel altar [55]. It is clear, however, that much work remained to be done. The vaults of the aisles, for example, were not inserted for another forty years. Some of the windows were unglazed and the enormous east window remained incomplete and empty of stained glass. The loss of Thoresby's enthusiastic interest and financial support resulted in a dramatic slowing down, if not cessation, in the pace of work.

His successor, Alexander Neville (1373–88), remembered for his quarrels with the Bishop of Durham, the Canons of Beverley and his own Chapter, showed little interest in his cathedral church. Nor could effective leadership be expected from the Deanery, occupied by two absentees in the period 1366–85. Faced by a financial crisis and an absence of patronage, the Works Department reverted to a tried and tested solution. Stained glass of c.1340 salvaged, as we have seen, from an as yet unidentified location was used to fill some of the empty clerestory windows [56]. A collection of figures and narrative panels of exceptional quality, discussed more fully above, were installed in the three easternmost clerestory windows on the south side (windows S2–S4). Window S2 has since lost this glass, but it remains in windows S3 and S4, while other panels have found their way into the north aisle (n4).

Just as in the nave, the reused glass was sited at a high level, leaving the more prominent lower level aisle windows for those donors who wished to be remembered for their piety and generosity. This elevated position protected these salvaged panels from the 1829 fire, which did so much damage in the choir and Lady Chapel, and accounts in part for the poor state of preservation of the original glazing of the Lady Chapel aisles. In windows s2 and s5 are the fragmentary remains of stained glass probably made c.1373 to prepare the Lady Chapel for use. Window s2 is devoted to the life of St John the Evangelist. In window s5 are the heavily restored figures of St James the Great, St Edward the Confessor and St John the Evangelist [57] under elaborate canopies of considerable interest. In common with illuminated manuscripts associated with the Fitzwarin Psalter (Paris, Bibliotèque Nationale Ms. lat. 765), the designer has abandoned the 'bird's-eye perspective' favoured in the 1330s and 1340s in favour of a three-sided superstructure topped by turrets and inhabited by figures. Side shafts are pierced with narrow lancets, wide niches contain figures and have visible vaults, angled to create the impression of projecting forms. The dormer roofs of the canopy tops are positioned diagonally to enhance perspectival effects, and barred

Above **56** Window S4, with its salvaged glass of *c*.1340, probably installed in Thoresby's Lady Chapel clerestory *c*.1370. The external tracery screen casts a shadow on the glass.

Below **57** Window s5, depicting St James the Great, St John the Evangelist and St Edward the Confessor (the last two seen here), is one of very few windows that can be assigned to the earliest phase of Lady Chapel glazing (*c*.1370).

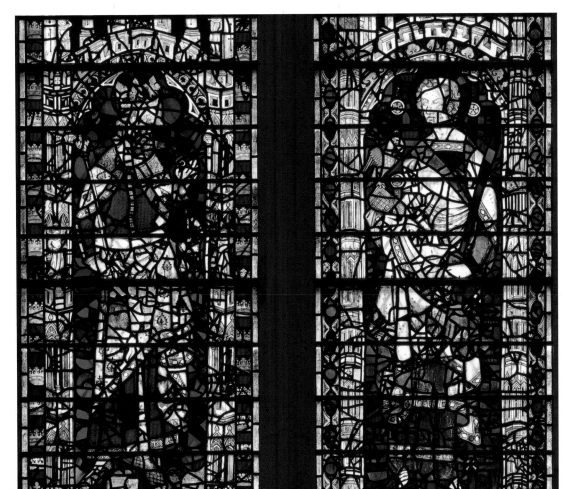

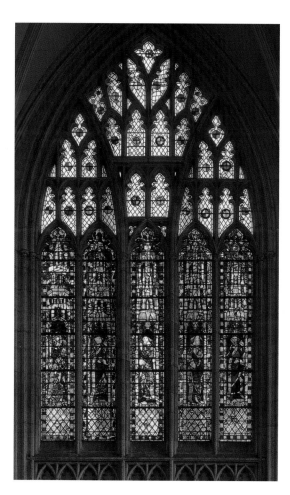

windows, with a variety of ironwork patterns, give depth
to the fictive masonry.

This window also preserves some fascinating examples
of stuck-on 'jewels', small pieces of glass attached with
fired glass paint to resemble the precious stones stitched
on to vestments and the richest royal garments. Sadly,
the glass used for these windows was otherwise of poorer
quality than that used by the glaziers of the previous
generation. During recent conservation of s2 it was observed
that it was made using the crown or disc technique rather
than the more common muff or cylinder method and has
corroded heavily, in marked contrast to the 1340s glass
close by. This may be another glimpse of the problems of
the post-plague period.

The windows of the north aisle appear to have been
glazed at a slightly later date, reflecting the renewed
impetus that followed Neville's removal and the election
of Archbishop Thomas Arundel in 1388. Arundel's
episcopacy coincided with the active and resident deanery
of Edmund Stafford (1385–95). Arundel was a generous
benefactor to his cathedral, in 1394 giving vestments,
ecclesiastical vessels and a reliquary containing two
thorns believed to be from the crown of thorns. Probably
dating from Arundel's episcopacy are the 15 figures
of apostles and prophets in clerestory windows S5,
N4 [58] and N5. The apostles hold curling ribbons
with sentences of the Creed, while the prophets hold
messianic texts from the Old Testament. The series must
once have extended into the now empty windows N2 and N3, which together provide
the additional nine lights necessary to accommodate 12 apostles and 12 prophets.
That the Creed series was inserted at a later date than the reused 1340s glass in the
windows on the south side of the clerestory can be deduced from the rather awkward
arrangement of the series across four windows on the north side and only one on the
south. A more balanced arrangement of apostles on the south side and prophets on
the north might have been expected.

Comparison with other glazing schemes installed in the period around 1390,
notably those associated with the patronage of William of Wykeham, Bishop of
Winchester, and the workshop of Thomas Glazier of Oxford (New College, Oxford
*c.*1385 and Winchester College *c.*1393) confirms this dating for the York Creed figures.
The canopies of the York figures are remarkably similar to those at Oxford, constructed
from strongly drawn three-dimensional forms, with turrets and recessed windows,
although the York canopies lack the playful grotesques introduced into some of the
Oxford canopies.

The figure style of the York apostles and prophets, with their softly modelled
features [59 and 60] and large gesturing hands, is closest to the later stages of the New
College scheme, particularly the Jesse Tree made for the west window, probably *c.*1390.
This is in a noticeably softer style than the earlier antechapel figures, a style that
had come to dominate the workshop of Thomas Glazier by the time the Winchester
College windows were made in the early 1390s. In 1765 the York glazier William
Peckitt replaced the New College west window with a work of his own, retaining the
medieval glass in part payment for his work. The glass was subsequently acquired

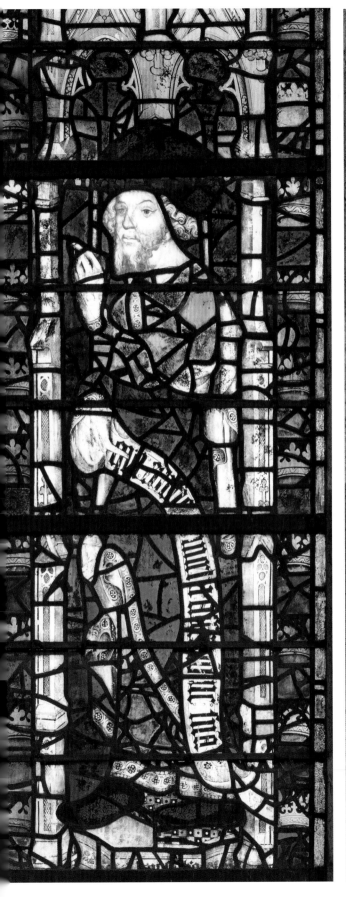
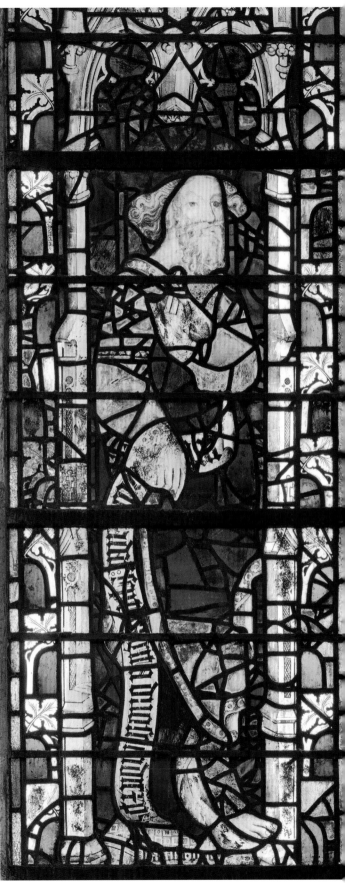

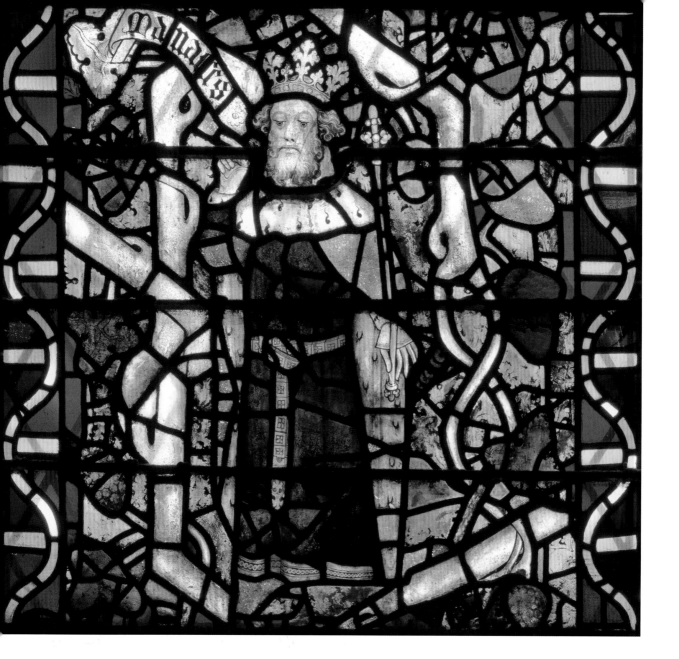

61 This figure of King Manasseh, made c.1390 for the west window of the chapel of New College, Oxford, by Thomas Glazier of Oxford, was installed in Minster window s8 in 1785 by William Peckitt.

for the Minster by Peckitt's patron, Dean John Fountayne (1747–1802), and it now fills window s8 [61], allowing a close stylistic comparison with the Lady Chapel to be made with comparative ease. Similarities are not confined to style, however. The late Dr French pointed out the close textual links that six of the York and Oxford prophets have in common, so close that the parallels include textual errors apparently introduced at Oxford and repeated in York.

The windows of New College and Winchester College were in two of the most important new buildings of their day and it is quite conceivable that the York glass painters had seen them. The relationships between the patrons involved were certainly very close. William of Wykeham had been a Canon of York early in his career. Between 1386 and 1391 the post of Chancellor of England was passed back and forth between William of Wykeham and Thomas Arundel, while Edmund Stafford, Dean of York, served as Keeper of the Privy Seal in 1389, becoming Chancellor in 1396, after his departure for the bishopric of Exeter. In 1397 Stafford's successor as Dean of York, Richard Clifford, became Keeper of the Privy Seal and in 1401 was succeeded in both roles by Thomas Langley, Dean of York, 1401–6. It is not difficult to envisage how the latest ideas could flow between London, Oxford, Westminster and York, and even

from further afield, for the York and Oxford figures also display all the painterly stylistic characteristics of a new 'soft style' adopted by painters in all media throughout Europe, dubbed by scholars 'the International Style'.

In the Minster fabric rolls, which survive with some gaps from c.1371 onwards, it is clear that the Minster's principal 'resident' glazier between 1399 and 1419 was John Burgh, to whom the Creed figures are usually attributed. J.A. Knowles, one of the first scholars to discuss the York windows in a wider national context, speculated as to the relationship between John Burgh and William Burgh, glazier to Richard II and Henry IV. In 1402 William was commissioned to make some of the most expensive stained glass ever recorded, to fill windows in Henry IV's new oratory at Eltham Palace, and in 1404 a John Burgh is recorded working at Eltham. Although Burgh's work in the Lady Chapel clerestory first introduced the softly modelled style of 'International Gothic' into the Minster, when the much-delayed work on the eastern arm resumed in 1394, he was to be overshadowed by a newcomer to the city and the glazing of the chapel's greatest window was to be entrusted to a 'foreigner', John Thornton, a native of Coventry.

THE GREAT EAST WINDOW

We know a surprising amount about the circumstances of the east window's creation. The original contract for its glazing was entered into a lost Chapter Act book covering the period 1390–1410. Fortunately a summary of it survives in one English version [62] and two Latin versions and reveals that in the winter of 1405 John Thornton, glazier of Coventry, was commissioned by the Dean and Chapter to make the east window of the choir, in return for the sum of £46, with a bonus of £10 on satisfactory completion within the specified three-year period. We can be confident that Thornton claimed his bonus because the date MCCCCVIII (1408) in Roman numerals appears in the glass at the apex of the window. The contract also provides a fascinating insight into Thornton's responsibilities. These included recruiting and managing a workforce of unspecified size, whose wages, together with the costs of materials, were to be borne by the Dean and Chapter, meaning that we do not know the size of the team who made the window or the overall cost of its creation. The contract does, however, reveal that Thornton was a skilled glass painter, for he was to paint those things 'where need required' according to the ordination of the Dean and Chapter. This suggests, however, that painting could also be entrusted to others, and the hands of several different highly skilled glass painters can be identified in the window [54].

The one aspect of the window's creation that could not be delegated was the process of cartooning, in other words creating the individual full-scale drawings from which every one of over three hundred stained glass panels were made. In signing the contract Thornton was 'obliging himself w[i]th his own hands to portrature [i.e. cartoon] the said window'. This process required the greatest skill of all, for not only did the 1:1 drawing ensure that the design translated into a full-size monumental work of art, but it also required extreme dimensional precision to ensure that the finished panel fitted perfectly into the requisite opening in the stone. All surviving medieval glazing records show that it was always this 'portraying' process that was entrusted to those men termed 'masters', who received higher rates

62 James Torre's c.1690 English translation of the medieval contract for the Great East Window, commissioned from John Thornton in the winter of 1405.

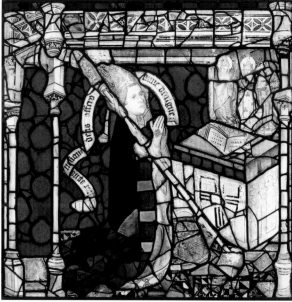

63 The arms of Archbishop Richard Scrope and Bishop Walter Skirlaw displayed in stone side by side in the spandrels of the south choir arcade.

64 Walter Skirlaw, Bishop of Durham, the donor of the east window, who appears at its base. His arms decorate the altar frontal at which he kneels. His lost head was re-created from antiquarian and internal evidence uncovered during the 2011–16 conservation of the window.

of pay for this process even if they were also, on occasion, paid to paint the glass too. It is likely that in 1405 this process was committed not to paper but to a large wooden table surfaced with a white chalky medium comparable to gesso. In the Westminster and Shene palace workshop inventories of 1443, for example, these glaziers' tables were made of wainscot and poplar and were supported on trestles. The relatively cumbersome nature of the glaziers' 'portraying tables' meant that they were not easily portable or easily stored, and could not be prepared very much in advance of the glaziers and glass-painters starting to work on them. We also know that the tables were washed and reused as the work progressed. The contract ensured, therefore, that Thornton remained close by at all times, translating any preliminary drawings into the full-scale cartoons and managing the throughput of work required to keep his team of glaziers and glass painters busy and able to deliver the project on schedule. During the recent conservation of the window it quickly became clear that it was overwhelmingly for his dual skills as an outstanding designer and as a project manager that Thornton's services were secured.

We can only speculate as to how Thornton was recruited for this most demanding project. It would seem that no glazier in York was deemed to have the right mix of skills needed for success. Medieval Coventry was also a major centre of glass painting and both Archbishop Richard Scrope (1398–1405) and Walter Skirlaw, Bishop of Durham (1388–1406), the donor of the east window, had served as Bishop of Coventry and Lichfield. It was probably Scrope, who had only recently been translated to York from Coventry, who effected the introductions. In fact, the older man, Walter Skirlaw, had been elected Archbishop in 1398 but was set aside in favour of Richard Scrope, a member of the powerful Scrope family of nearby Masham, whose members quickly became major patrons of the Minster. Despite this reversal, Skirlaw remained a generous patron of the Minster, for his arms appear alongside Scrope's archiepiscopal shield in the first south bay of the new choir [63], where work on the unfinished eastern arm resumed, and were also featured prominently in the new crossing tower. The money for the east window is not mentioned in Skirlaw's will, made in 1403 with later amendments, but there is no doubt of his donation, as his portrait, arms and dedicatory inscription appear in the window itself [64]. That he had passed the necessary money to the Minster by 1405 can be deduced from the contract, which was negotiated by

the Dean and Chapter rather than by the Bishop's representatives. In the event neither Scrope not Skirlaw lived to see the great work completed.

The nine-light east window is the biggest single expanse of stained glass in the Minster, visible in both Lady Chapel and choir. Its subject, rare in stained glass, is appropriately ambitious, the history of the world from the beginning to the end, drawn from the first and last books of the Bible. The scene is set at the apex of the window in which a figure of God enthroned in the midst of a heavenly host holds a book inscribed with the Latin words *Ego Sum A[lpha] et O[mega]* (I am the Beginning and the End [65]). In the three rows of main light scenes below the tracery and immediately above the transom gallery that runs across the window, are 27 Old Testament scenes from the first day of Creation (Genesis 1 [66]) to the death of Absalom (2 Samuel: 18). Beneath the gallery are 81 scenes taken from the Book of Revelation (known in the Middle Ages as the Apocalypse [67, 69–71]), while the nine panels at the base of the window depict the kings, popes and archbishops revered in the history of the church of York, three figures per panel, with the donor, Bishop Skirlaw, kneeling on his own in the central panel, immediately beneath the feet of Christ in Judgement.

We may be sure that the ideas behind the creation of this great work lay not with Thornton but in the circle of theologians around Archbishop Scrope and Bishop Skirlaw and the learned members of the early fifteenth-century Chapter of York. It may even reflect ideas first contemplated by Archbishop Thoresby, for it is inconceivable that no thought had been given to the message to be conveyed in such a great wall of glass, which, in turn, is the key to the rest of the imagery of the new choir. Recent research by Nigel Morgan has demonstrated that the iconography of the Great East Window was informed by the imagery of two separate 'families' of illuminated manuscripts, some of them dating to the middle years of the thirteenth century, although how their content was communicated to John Thornton remains a matter of speculation. The historical figures for the base panels [68] were chosen from a variety of carefully researched sources, including Bede's eighth-century ecclesiastical history and Geoffrey of Monmouth's twelfth-century *History of the Kings of Britain*, which in turn had informed the 'official' Minster history composed in the period 1388–97 and which until the seventeenth century could be consulted in the Minster on the wooden boards known as the tables of the vicars choral. This rooted the great biblical narrative in the medieval Minster community, the successors and spiritual heirs of those who brought the light of Christianity to the north of England. Taken together, these subjects would have been understood by a medieval theologian as representing the Seven Ages of the World, after which the Book of Revelation promises, in its final chapter, that there will be a new heaven and a new earth.

Close scrutiny of the relationship between glass and stone has also revealed a complex number symbolism, which can only have come about through the direction from above of both masons and glaziers.

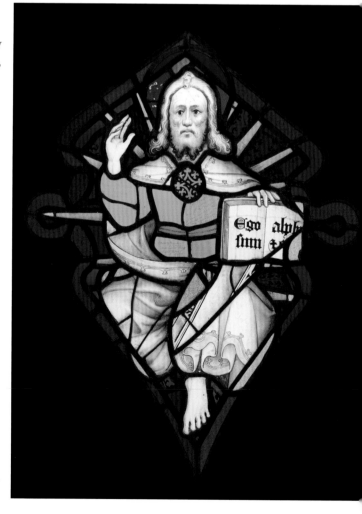

65 God the Father at the apex of the Great East Window, with the words *Ego sum A[lpha] et O[mega]* (I am the Beginning and the End), summarising the entire message of the window.

66 The first day of Creation: God the Father divides light from darkness while Lucifer and the rebel angels fall from heaven.

The window tracery is subdivided both vertically and horizontally into three, the number of the Trinity and a number of abiding Christian significance. The window is of nine lights (3 × 3), while its traceried head contains 144 glazed openings, recalling the 144 cubits that measured the heavenly Jerusalem and the 144,000 witnesses described in the Book of Revelation. Three times nine equals 27, the number of Old Testament panels, separated from the Apocalypse cycle by the transom gallery (the position of which was altered during construction to create this architectural subdivision), while 9 times 27 produces 81, the number of Apocalypse panels. It is hard to believe that this was entirely coincidence!

None of these observations detracts from Thornton's considerable imaginative and creative skill as a stained glass designer, nor from the artistry and expertise of his team of painters and glaziers. Although the biblical narrative in the window is read like a book, left to right from top to bottom, this version of the Apocalypse must work as image without text, and must be strictly contained within its stone framework. With only 81 scenes allocated to the Apocalypse (the almost exactly contemporary Westminster Abbey chapter house paintings had 96 scenes), Thornton and his

67 The dragon and the beast (Revelation 13:1–3).

collaborators were forced to edit the text carefully. Some episodes – God worshipped by the Elders (Revelation 4: 1–3, 5–8), for example – are afforded several panels, while others, such as St John writing to the seven churches (Revelation 1: 11 and 20), are cleverly compressed into one. The text was read with extraordinary care: in the scene of the mighty angel and the seven thunders, for example, the angel is shown, as described in the text (Revelation 10: 1–7), with one foot on the sea and one on the land, while the book is thrust into John's mouth as he is instructed to eat it and to prophesy, an instruction that is carefully abbreviated in the perfectly inscribed Latin text scroll [69]. This raises the question of the degree to which Thornton could access the texts for himself. Levels of Latin literacy among craftsmen and artists have been very little researched, but by 1405 the Bible was available in English translation, the Wycliffe Bible of 1388. Although it was outlawed in 1401, we cannot discount the possibility that Thornton was familiar with the Apocalypse text in his own language. For surely only someone who has read and reflected on the text of Revelation 1: 12–17, the Son of Man seated among the seven candlesticks, and its implications for image-making, could have achieved such a precise and legible composition, far more

68 At the base of the window, flanking the donor, are a series of historical figures of kings, popes and archbishops. Here we see William the Conqueror, Edward the Confessor and Edward III, each one accompanied by a coat of arms, although Edward III sits above the arms of Henry IV.

accurate than a number of manuscript versions [70]. The mouth of the Son of Man is pierced by the sharp two-edged sword in accordance with the text. The skilful use of silver stain has ensured that his face shines like the sun, while his hair (and beard) remains as white as snow. His girdle is shown uncomfortably high, 'girt about the paps' as the text describes. Thornton makes no attempt to arrange the seven stars in his right hand, as required by the text, realising that from the pavement of the Minster this detail would be invisible. Instead, the stars are displayed amongst the branches of the candlesticks on his right side, silhouetted against a brilliant red background.

In the past the window has often been criticised as being illegible from the ground, although the earliest witness to its content, James Torre, was able to describe even its highest panels with astonishing accuracy and there is no evidence that he had any visual aids or access to scaffolding. The deterioration and darkening of some of the medieval glasses (notably the greens and the purples), the disturbance of the original compositions, the introduction of mending leads in the 1820s and 1950s and damage in the 1829 fire certainly did nothing to improve legibility, further exacerbated by exceptionally heavy post-war re-leading. The introduction of external diamond quarry glazing provided invaluable protection but further dulled the window. These issues have all been addressed in the recent conservation of the window, ensuring that once again the window both envisions and embodies the heavenly Jerusalem, a structure of light and jewelled colour [71]. The Great East Window played a vital role in establishing the medieval Minster's claim to be an earthly foretaste of the heavenly splendours to come.

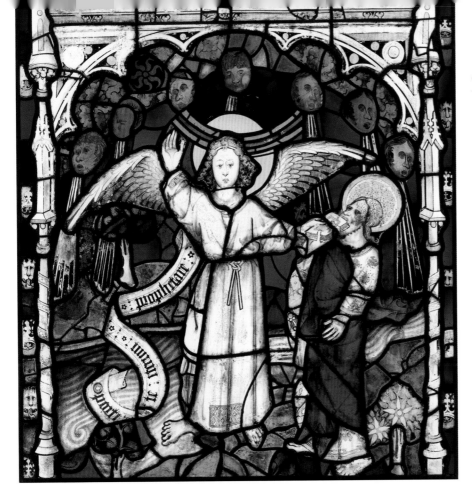

69 John takes the book from the mighty angel (Revelation 10: 8–11).

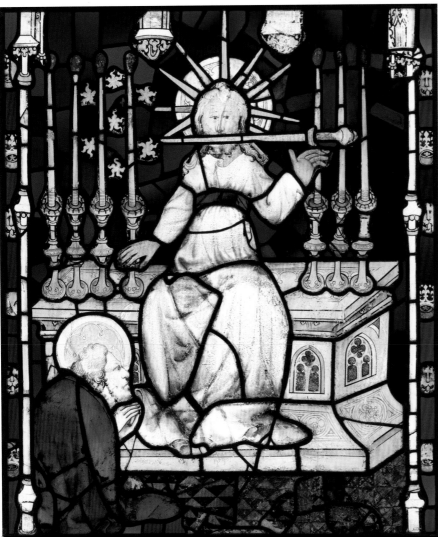

70 The Son of Man (Revelation 1: 12–17).

71 The Apocalypse cycle of the Great
East Window (rows 7–12) following recent
conservation (2011–16).

THE WESTERN CHOIR

John Thornton remained in York after the completion of the east window. In 1410 he was made a Freeman of the City, essential if he was to undertake commissions for patrons other than the Dean and Chapter. Glass in what has been described as 'Thornton's style' is to be found in a number of the City's parish churches, in addition to locations further afield in both the North-East and the Midlands. It is now appreciated that not all glass in the so-called 'York style' originated in York or in the workshop of John Thornton, although it is known that he retained property in Coventry and probably continued to run a business there. Perhaps his greatest influence was felt in York, however, where he was still living in 1433, residing in a Stonegate property owned by the Dean and Chapter.

Only the east window is a documented work by John Thornton. Much work remains to be done on the style and workshop practices of Thornton and his associates, but the visual evidence supports the supposition that he was to have a strong influence on and probably a direct involvement in the glazing of the clerestory and aisles of the five bays of the western choir. In the St William window of c.1414 (n7, [72, 73, 77, 78, 79]), in particular, the stylistic hallmarks and design ingenuity of Thornton can be recognised, although there is no proof of this connection. Only the later St Cuthbert window (s7) in the equivalent location in the south-east transept, is clearly the work of another (later) team of glass painters.

The building of the western choir was the second stage in the redevelopment of the eastern arm. For some twenty years after Archbishop Thoresby's death the western bays of the twelfth-century choir continued in use. In 1394 the old choir was finally abandoned and services transferred to the new vestries on the south side. The old choir was finally demolished and the new choir rose up in an east-to-west programme, finally linking the Lady Chapel extension to the crossing. By 1399 night watchmen were needed to safeguard what must have been an open building site, and a capital on the south-east crossing pier was decorated with the white hart emblem of Richard II, who visited the Minster in that year. The first bay of the new choir, encompassing the choir transepts, must have been completed at least to triforium level after 1398 and before 1405, because in the spandrels of the arcade are the arms of Archbishop Richard Scrope, elected in 1398 and executed by Henry IV in June 1405, accompanied by those of Bishop Walter Skirlaw (d.1406 [64]).

Progress was checked by the collapse of the central tower, recently re-dated to late 1405. The extent of the damage is unclear but the emergency was sufficiently serious to prompt the division of the workforce, with one team working on the choir and the other on the stabilisation and reconstruction of the crossing. In 1407 work was taken out of the hands of Minster master-mason Hugh Heddon and entrusted to King Henry IV's mason William Colchester. Heavy expenditure on building materials and the wages of the workforce show that work on the choir continued until at least 1420, a date supported by analysis of the heraldic evidence. The display of shields in the spandrels of the arcade, begun in the nave and continued into Thoresby's Lady Chapel, was now extended into the choir. Heraldry also figures prominently in the lowest tier of panels in the clerestory windows.

The fire of 1829, which fed on the wood of the medieval choir stalls (which were totally destroyed) also did considerable damage to the stained glass, especially on the south side. Nonetheless, eight windows in the clerestory (N8–N11 and S8–S11), three windows in the north aisle (n8–n10), one window in the south aisle (s9) and the huge windows of the choir transepts (n7 [the St William window], N6, N7, s7 [the St Cuthbert window], S6 and S7) survive.

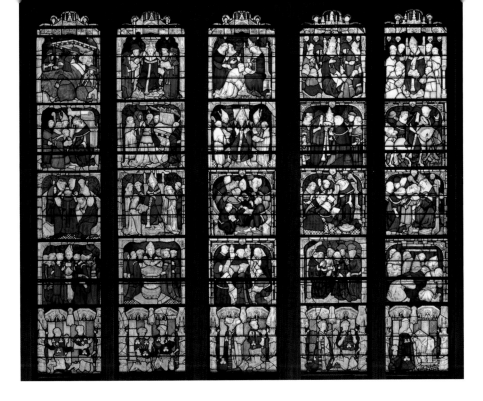

72 The bottom tier of scenes in the St William window (n7), donated *c.*1414 by Beatrice, Dowager Countess of Ros (d.1415).

The windows in the choir celebrate the triumph of Christianity in the north of England in general and the crucial role in this story of the cathedral church of York in particular. The medieval high altar was lit by windows that portray the lives and miracles of St William (n7) and St Cuthbert (s7), but recessed in the choir transepts as they are, the windows would have been fully visible only to those celebrating mass. The most detailed exposition of the message is to be found in the clerestory windows, shining light onto the daily assembly of the canons and the choir of the cathedral community seated in the stalls below – a luminous reminder of their historical and spiritual legacy. Despite the loss of many of the identifying labels, it is clear that the scheme represents those figures significant to the history of the Church in the Northern Province from earliest times to the Anglo-Saxon conversion, with the majority of figures dating from the seventh and eighth centuries. This is the period described so vividly in Bede's *Ecclesiastical History of the English Nation*, completed in 731, when York was capital of the Anglo-Saxon kingdom of Deira. Each window contains historical figures under canopies, above a shield of arms commemorating a contemporary donor, many of whom can be identified as members of the Chapter and of the local nobility. The heraldry in the windows supports a date of *c.*1408–*c.*1414 for this part of the glazing scheme, suggesting that work continued without pause after the completion of the Great East Window.

In each five-light window the figures were arranged in the same way – bishop or

73 Beatrice, Dowager Countess of Ros, shown kneeling at the bottom right-hand corner of the St William window.

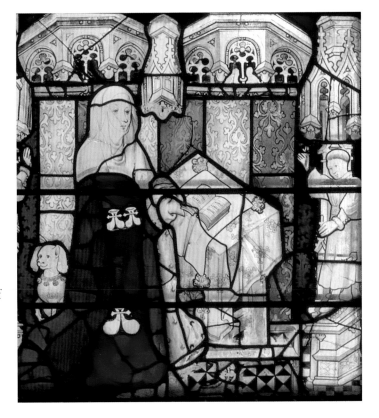

archbishop, king, pope, king, bishop or archbishop. Windows N11 and S11, nearest the crossing tower, have only four lights. The figures are arranged chronologically, with the earliest identifiable figures in window S11 – King Lucius of the Britons in the fourth light, who according to Bede, wrote to Pope Eleutherius (c.174–89), who appears in the third light, requesting help in converting Britain to Christianity. In window N11 [74] is the figure of a king holding a scroll with the words *Anglie et Francie* ([King] of England and France), a title first claimed by King Edward III in 1340. The shield beneath his feet is that of England in the form adopted by Henry IV in 1406 and the features of the King bear a resemblance to those on the effigy of Henry IV on his tomb in Canterbury Cathedral.

The care taken in the choice and arrangement of figures can be most easily appreciated in the windows on the north side, which are best preserved. In window N8 [75] St John of Beverley, Bishop of York (705–17) and his successor St Wilfrid II (717–44) are accompanied by the saintly King Ceolwulf (729–37) and his successor King Eadberht (737–48), brother of Archbishop Egberht of York, Wilfrid II's successor and one of Bede's former pupils. The pope is unidentified, but the saintly Pope Gregory II (715–31) must be a candidate. The heraldry in the lower panels identifies the donors as members of the Bowet family, relations of Archbishop Henry Bowet (1407–23). In window N9 the two archbishops are St Wilfrid, Bishop of York in 669 (d.709), and St Bosa (d.705), who succeeded him after his deposition. Pope Agatho (678–81), in the centre light, is the pope to whom Wilfrid appealed in 679 and who found in Wilfrid's favour. The kings are Oswiu (655–70), who presided over the Synod of Whitby in 664 – in which the cause of the Roman Church triumphed over the customs of the Celtic tradition, a debate in which Wilfrid played a decisive part – and his son, King Aldfrith (685–705). The heraldry identifies the donor of the window as Henry, 3rd Lord Scrope of Masham and nephew of Archbishop Scrope, and dates it to the period 1411–15, when he briefly adopted a differenced version of the famous Scrope of Masham arms, which also appear in stone in the same bay. Henry was executed for treason against Henry V in 1415.

The quality of the execution of the western choir clerestory windows is variable, far less consistently accomplished than either the east window or the St William window. It is clear, however, that the windows were designed as a single programme. They are not identical in detail. The canopy designs and the frames around the shields in the lower panels on the north and south sides are different, for example (S10 [76]). There is, however, a noticeable reuse of cartoons on both sides of the choir, indicative of close workshop collaboration. The cartoon of the king in the second light of window N9, for example, is also used for the king

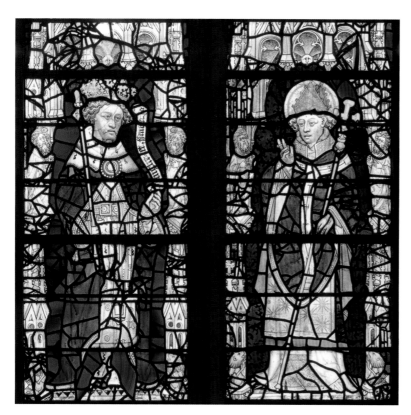

74 A King of England (a likeness of King Henry IV?) and St Paulinus in choir clerestory N11.

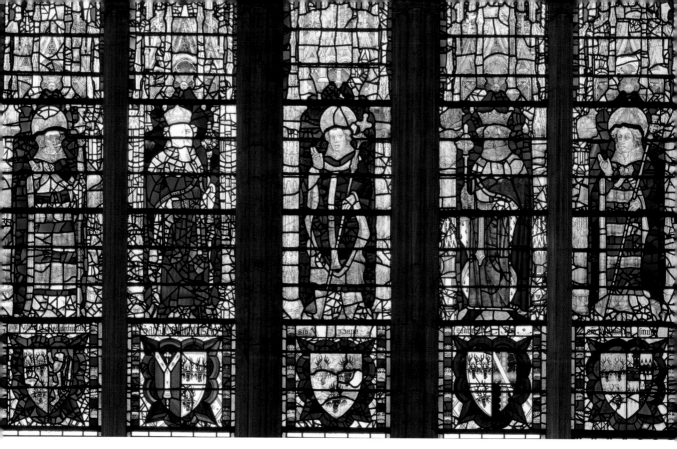

in the second lights of N8 and N10, while the pope in the centre light of N8 is also used in the centre light of N9 and N10 and the fifth light of S8.

The choir transepts contain windows 75 ft in height, an expanse of glass rivalling the great windows at the east and west ends of the cathedral. The cost of filling these windows with stained glass was prodigious, but their proximity to the high altar made them an attractive prospect for a pious donor. As the glazing of the clerestory windows drew to a close, the Dean and Chapter secured a donor for the window on the north side (n7). The honour of paying for the most extensive pictorial cycle of the life, death and miracles of St William, the Minster's 'resident' saint, whose shrine behind the high altar was the largest ever made in England, was claimed by the Ros family. The family of Ros of Helmsley had long been associated with the Minster fabric. Their arms can be seen in the nave clerestory windows, among the stone shields in the nave arcade, in the windows of the Lady Chapel and in the Lady Chapel arcade. The Ros shield was also included in the paintings added to the Chapter House vestibule *c.*1396, when Richard II came to York to grant the city charter. Here the Ros lords are shown in company with the King, Bishop Skirlaw and the Percys, also long-standing benefactors of the Minster. The base panels of the St William window depict nine members of the Ros family, dressed in heraldic surcoats and capes [72]. The donor of the window is likely to have been Beatrice, Dowager Countess of Ros (*née* Stafford), mother of William, the 6th Baron (d.1414), who outlived her son, dying in 1415. She kneels alone at her prie-dieu, facing eastwards at the head of her family, although her little dog looks backwards to the rest of the family lined up behind her [73].

Above the donor panels, enclosed in rectangular architectural frames, are 95 narrative panels recounting the story of St William from his birth to the miraculous events that occurred at his shrine. St William's life was not one packed with the sort of incident easily translated into a picture cycle [77]. The most prominent events concern juridical disputes, in which the Archbishop was finally vindicated and reinstated to his see. Indeed, his triumphant return to York was the occasion of one of his most famous

75 Window N8, the gift of Archbishop Henry Bowet (1406–13) and his family. The figures, not all of them identifiable, have been made from the same cartoons as figures in N9. The historical figures all belong to the eighth-century history of Christianity in the North.

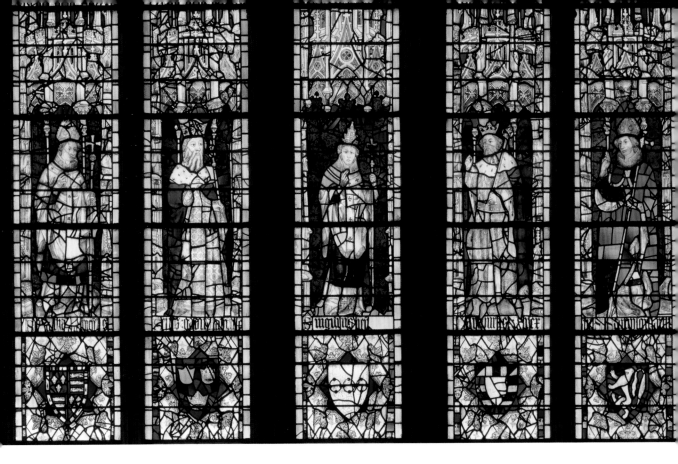

76 Window S10, containing the arms of Cardinal Beaufort, half-brother of Henry IV, and the arms of Minster Treasurer Thomas Haxey (1418–25). The canopies are of a different design from those on the north side.

Opposite
77 The Holy Spirit visits William in solitary prayer (n7).

78 A pilgrim at the shrine of St William in York Minster (n7). While the depiction of the shrine itself cannot be considered architecturally precise, the practice of adorning shrines with models of afflicted and cured body parts in wax or precious materials is well attested.

miracles, when he intervened to save those who had fallen into the river from the collapsed bridge over the Ouse.

In common with the earlier Becket miracle cycle in the windows of Canterbury Cathedral, the St William window emphasises those miraculous events associated with St William's tomb and shrine, a reminder of the healing efficacy of a visit to the Minster. In several scenes pilgrims are shown offering models of those body parts for which a cure was sought and the shrine is shown surrounded by the models, some of them in precious metals, but most in wax [78], similar to those actually found at Exeter Cathedral. The shrine depicted in the window conforms to a standard later medieval form, a base with gables and niches, into which the pilgrims could press themselves in order to gain closer access to the enshrined saint, and with an altar table at the west end. In the Yorkshire Museum are the fragmented remains of William's two shrines, the fourteenth-century nave shrine paid for by Archbishop Melton and the far larger and grander structure that from 1472 stood one bay east of the St William window behind the high altar.

The St William window is of such exceptional and consistently high quality that there can be little doubt that it is the work of John Thornton [79]. The window displays many of the stylistic characteristics of the Great East Window and the same ingenuity of design identified as the hallmark of Thornton's genius. It shows the same talent for the expansion and contraction of narrative. The bloody combat between Ralph and Besing, leading to the innocent Ralph's blinding and the restoration of his sight by St William, is accorded five scenes in row 12. The deaths in 1153 of William's opponents, Archbishop Murdac, Saint Bernard of Clairvaux and Pope Eugenius III, clearing the way for William's reinstatement to the see of York, is compressed into three deathbed scenes ingeniously arranged in a single panel. The conservation of the window, completed in 2007, not only improved the legibility of the scenes by replacing disastrously thick leading and removing many mending-leads, but also responded to new research by Professor Norton into the sources of the window, allowing its correct narrative order to be reinstated.

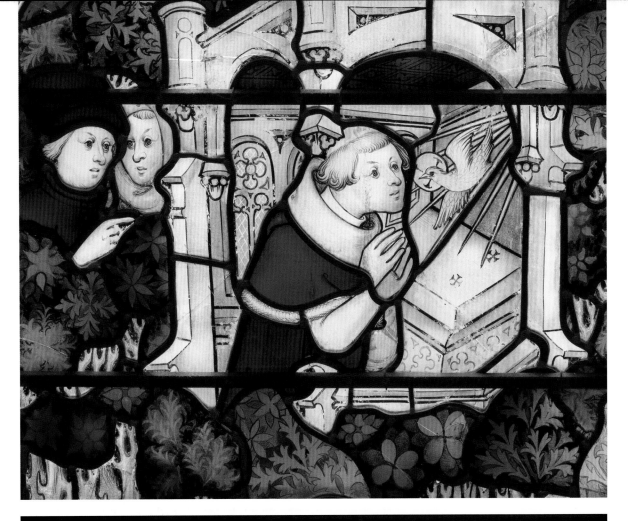

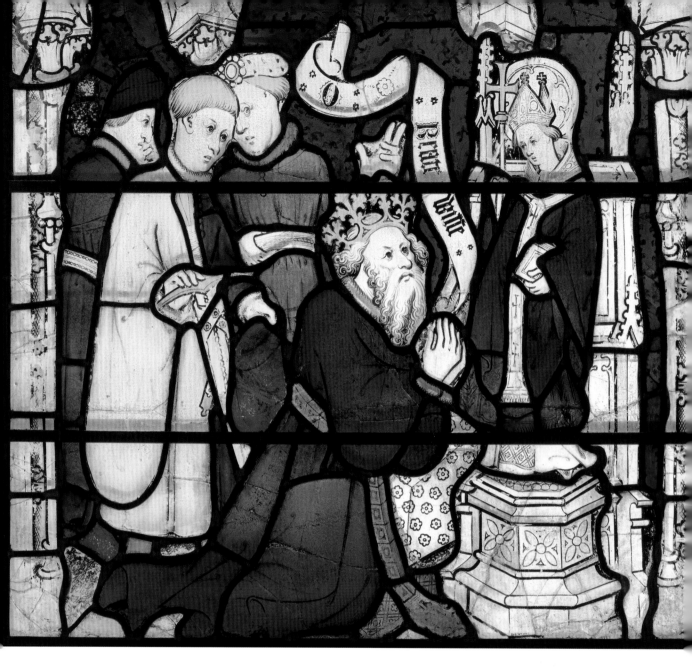

79 During the translation of St William's relics in 1284, King Edward I suffered a fall and was healed by the intercession of the saint, to whose image he is shown at prayer (n7). The quality of the window leaves little doubt that it was made by John Thornton and his associates.

The political uncertainties of the early years of the fifteenth century made a glazing scheme that celebrated the saintly ecclesiastics and kings of the distant past a very attractive choice to the York Chapter. In September 1399, when work on the choir was well under way, Richard II, a benefactor of the Minster and granter of the city's charter, whose white hart emblem decorates the south-east crossing pier, was deposed and supplanted by his cousin Henry Bolingbroke. Henry was crowned as Henry IV. Archbishop Richard Scrope, whose brother Stephen, 2nd Lord Scrope of Masham, had been a close associate of the deposed King, had advised on the legal justification for the deposition and accepted Richard II's renunciation of the throne. In 1403 he celebrated high mass in the Minster in the presence of the new King. However, by the summer of 1405 Henry's excessive taxation caused Archbishop Scrope to lose faith in the new King and he placed himself at the head of a rebellious citizen army, resulting in his own execution and the temporary loss of the city's privileges. After his decapitation at Clementhorpe on 8 June 1405, the Archbishop escaped the fate of his co-conspirators, whose heads were placed on the city gates. Instead, his body was borne to the Minster for burial in St Stephen's Chapel, a space

in which several members of his family were also buried, so that the chapel became known as 'Scrope Chapel'. Any plans the Archbishop may have had for a prestigious tomb in a location between St Stephen's chapel and the Lady Chapel were thwarted by his untimely death, but his modest grave was soon the site of miracles and attracted large numbers of pilgrims. King Henry had made a grave error of judgement in proceeding so quickly and ruthlessly to execute Scrope without due process and in the face of legal advice. The execution had taken place on St William of York's feast day, a spectacular PR disaster, and the death of Scrope at the hands of one King Henry invited comparison with the death of Thomas Becket in 1170 at the behest of another. Would-be pilgrims were discouraged by the erection of a barricade of logs and stones, but the cult grew, with support from both Minster clergy and many of York's better-off citizens.

No member of the clergy could possibly condone the execution of an anointed Archbishop, but nor could they easily support the violent overthrow of an anointed King, especially one who emerged from the crisis as the military victor. It is clear that in the aftermath of the Scrope rebellion both the Minster clergy and the civic elite were in turmoil. The Archbishop had been popular with both the Minster clergy and the citizens of York. Five vicars choral and a Minster chaplain had joined the rebellion, and it was the vicars choral who had carried his corpse back to the Minster. Nonetheless, in the early years after his accession, the new King had striven to fill the church with as many of his own supporters as possible, and as a result the most important members of the Chapter were staunch Lancastrians, notably Dean Thomas Langley (1401–6) and Dean John Prophete (1406–16). Henry had first hoped to see Langley made Archbishop but the Pope refused to co-operate, sending Langley to Durham instead. Henry then resisted all other papal provision and eventually secured the translation of Henry Bowet from Bath and Wells [80]. Bowet was one of Henry's oldest and most loyal supporters and in 1413 the recently deceased King was remembered in the chantry founded by Bowet in All Saints' Chapel, where his splendid tomb was located, directly opposite the Scrope Chapel, where Archbishop Richard's body continued to attract pilgrims. Bowet, himself a northerner, served as Archbishop until his death in 1423 and deserves credit for his part in restoring order and stability in the city and diocese.

80 Archbishop Henry Bowet, donor of n10. Although not King Henry IV's first choice to succeed Archbishop Scrope, he had long been a Lancastrian supporter.

Although the Scrope family continued as benefactors of the cathedral, Scrope's relatives seem initially to have been careful not to be seen to be promoting his claims to sanctity. Support for the cult was strongest among the wealthier citizens of York, who revered Scrope for his chastity and charity. At least two books of hours in the possession of mercantile families in York celebrated 'St Richard' and wills of the time record a number of bequests of relics associated with him. The rebels of 1405 had included many North Yorkshire knights from families that had traditionally supported the Minster fabric (including the Hastings, FitzRandolph and Colville families, who are all commemorated in the nave). That Henry's vengeance against the city was not more severe and long-lived owed much to the skilful diplomacy of the city government and the prompt payment of a large fine. Nonetheless, tensions must have run high in the aftermath of the rebellion.

The fall of the crossing tower in the winter of 1405 and its aftermath gave Henry an opportunity to display his generosity and placate public opinion in York. In 1407, with work progressing slowly, master mason William Colchester was sent from London by the King to take charge. Colchester and his servants were unpopular and suffered

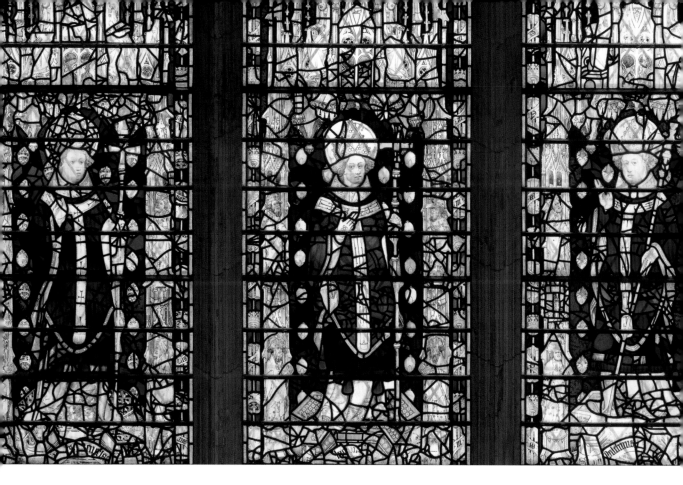

81 The three saints chosen by Canon Thomas Parker, Prebendary of Ampleforth, for n9 were St John of Beverley, St Thomas of Canterbury, his name saint and St William of York.

physical abuse at the hands of their fellow masons. While this action might have been an expression of professional jealousy, an antipathy to Colchester's royal master might also have been a factor. Whatever the explanation, it is clear that the glazing of the choir was being planned and executed at a time of extraordinary tension in the city, with the Chapter attempting to chart a course through a potential minefield of devotional and political sensibilities.

The glazing of the choir aisle windows, at eye level and therefore especially visible to those passing into or out of the choir, neatly avoided all controversy in their choice of subject matter. The design of the windows, which are best preserved on the north side (n8–n10), was identical, and their stylistic homogeneity, linking them to the St William window (n7) to the east, suggests that the windows were glazed in a single campaign. Archbishop Bowet, who had already contributed to the clerestory glazing, gave a lead, donating window n10. He was joined by Thomas Parker, Prebendary of Ampleforth (1410–23), and Treasurer Robert Wolveden (1426–32). A date in the 1420s has been suggested for these windows, based on the date of Wolveden's treasurership. He had a long career in the Minster hierarchy, however, having become Prebendary of Knaresborough in 1400, a position he exchanged for that of Prebendary of Wetwang in 1408, and on historical and stylistic grounds a date closer to 1415 seems more likely for these three windows.

Bowet chose St Peter, St Paul and the Virgin Mary for his window. St Peter and St Paul are the two saints most commonly represented on the seals of the Archbishop of York, sometimes accompanied by St William of York. Bowet's seal gives pride of place to the Virgin Mary, the first among heavenly intercessors, who is flanked, as in the window, by St Peter and St Paul. Thomas Parker, donor of window n9, was also rector of nearby Bolton Percy and rebuilt and glazed the chancel there, a measure of his considerable wealth as a residentiary Canon of York. His window commemorates two of the Minster's sainted archbishops, St John of Beverley and St William, and

his own name saint, St Thomas of Canterbury [81], including a unique depiction of Thomas as Chancellor (1155–62). Robert Wolveden chose St Chad, St Paulinus and St Nicholas of Myra for his window (n8). In the choice of Paulinus, first Bishop of York, and Chad, first Bishop of Lichfield, Wolveden was reflecting the dual aspects of his own ecclesiastical career as Precentor of Lichfield from 1390, Canon of York from 1400 and both Treasurer of York and Dean of Lichfield from 1426 [82]. He had been one of those who needed to seek pardon after the 1405 rebellion and remained loyal to Scrope's memory, although under Bowet he enjoyed a very successful career and became a generous benefactor to the Minster.

In the final phases of the glazing of the choir, the fruits of reconciliation under Archbishop Bowet and the new King, the popular and successful Henry V (1413–22), can be discerned. Henry had interred the body of Richard II in Westminster Abbey, its intended royal resting place, and had finally fulfilled his father's penance for the death of Archbishop Scrope by founding three religious houses. Window S6 was the gift of Stephen Scrope, Archdeacon of Richmond (1402–18), nephew of the executed Archbishop, and contains a large image of Archbishop Richard Scrope, to whom a prayer is addressed, as if to a saint [83]. The window is faced by a window of the same date given by Robert Wolveden, which depicts St William. The rehabilitation of Archbishop Scrope was now more actively promoted by his family and its wider circle, many of them members of the Corpus Christi Guild, and was undoubtedly encouraged by the fact that his burial place in the Minster was proving to be a financial asset to the Minster – the offerings at his grave considerably exceeding those at St William's shrine. In 1459 Thomas, 5th Lord Scrope of Masham, established a new chantry in St Stephen's chapel, already the place of burial of at least two other Scrope lords, as well as Archdeacon Stephen Scope, who was buried next to the Archbishop. The chapel was refurbished, perhaps acquiring its new east window (n2) at this time, and it is likely that the Archbishop was also finally provided with a proper tomb chest.

82 Treasurer Robert Wolveden, donor of n8, chose as subjects for his window St Chad, first Bishop of Lichfield, where Wolveden was Precentor and subsequently Dean, St Paulinus, the first Bishop of York, and St Nicholas of Myra.

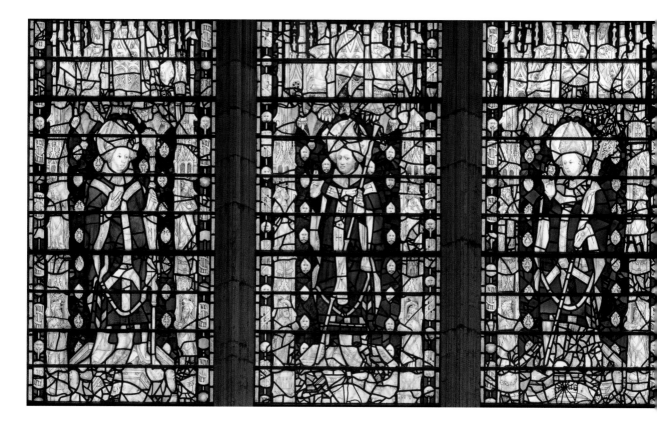

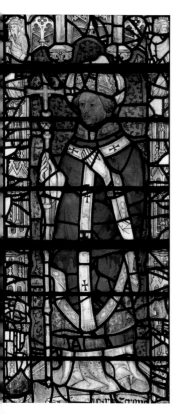

83 Archbishop Richard Scrope (1398–1405) depicted as a saint in S6. The window was the gift of his kinsman Stephen Scrope, Archdeacon of Richmond (1402-18).

84 A Lancastrian 'Who's Who' fills the lower part of the St Cuthbert window (s7). The window was the gift of Thomas Langley, former Dean of York, and from 1406 until his death in 1437 Bishop of Durham, centre of St Cuthbert's cult.

The image of Archbishop Scrope, a victim of the Lancastrian monarchy, was eventually joined in the south choir transept by a window that celebrated that dynasty. The main subject of window s7, the gift of Thomas Langley, Bishop of Durham, former Dean of York and executor of John of Gaunt, Bishop Walter Skirlaw and King Henry IV, is the life and miracles of St Cuthbert. A large figure of St Cuthbert, carrying the head of St Oswald, is surrounded by Lancastrian kings and members of the Lancastrian episcopate [84] in an extraordinary display that occupies a third of the window. In the lower register are Archbishop Henry Bowet (d.1423), Cardinal Henry Beaufort, Bishop of Winchester (d.1447), Humphrey, Duke of Gloucester (d.1447), uncle and protector of the young Henry VI, Cardinal John Kemp, Archbishop of York 1425–52, and Thomas Langley (d.1437) himself. In the row above are Henry V (d.1422), Henry VI (d.1471), John of Gaunt (d.1399), fourth son of Edward III and progenitor of the Lancastrian royal line, and Henry IV (d.1413), its first king. Bowet's loyalty to Henry IV had won him an archbishopric. Henry Beaufort, a cardinal since 1426, was Henry IV's half-brother and godfather to Henry VI, and he and Langley served as Chancellor to both Henry V and Henry VI. Kemp succeeded Beaufort as Chancellor to Henry VI.

Provision for the window is not mentioned in Langley's will of 1437, prompting nineteenth-century scholar J.T. Fowler to suggest that it was erected during his lifetime. There are problems with this early dating, however. Henry VI is depicted in the window as a crowned adult. He had succeeded his father in 1422, when less than a year old. Although his dual coronations as King of England and of France took place in 1429, when he was a child of eight, he was not declared to be of age until 1437, the year of Langley's death. Archbishop Kemp is described in the window as *Cardinalis Ebor*, a distinction he did not achieve until 1440, suggesting that the window dates to the early 1440s. In common with many windows on the south side of the cathedral, the St Cuthbert window has suffered damage. Indeed, J.T. Fowler even suggested that some panels had been deliberately defaced. Extensive repair and narrative re-ordering was carried out by J.W. Knowles in 1887 under Fowler's direction. Its legibility has certainly been diminished by the multitude of heavy mending leads. The quality of the glass painting is variable and generally of a lower standard than the earlier St William window, but the window was the product of a carefully considered programme of research, drawing upon the ancient and exceptionally rich imagery of the life and miracles of St Cuthbert of Durham [85], in whose cloister Langley had also provided a stained glass cycle of the saint's life. In comparison with the St William window, where the glaziers and their advisors had to generate a large and essentially new cycle of images, the creators of the St Cuthbert window had almost an embarrassment of visual and textual riches upon which to draw [86]. It is hoped that further research will shed light on the editorial process behind the window's conception.

The triumph of the Yorkists under Edward IV led to another shift in the fortunes of the Minster's imagery. Archbishop Scrope became something of a Yorkist hero. He is depicted as a saint in stained glass of *c*.1461–9 in the collegiate church of Fotheringhay in Northamptonshire, founded and endowed by the House of York. In 1462 the pursuance of his canonisation with the Papacy was seriously considered, but in the end came to nothing. If the triumph of the House of York improved the fortunes of the unofficial cult of Richard Scrope, it did little for that of the Lancastrian King Henry VI, also revered as an unofficial saint and commemorated on the stone choir screen. By 1479 an image of Henry VI in the Minster had become an object of veneration leading Archbishop Lawrence Booth to issue an admonition against any person expressing devotion to it. It is likely that the removal of the choir screen statue and the possibly deliberate defacement of the King's identity in the St Cuthbert window date from this time.

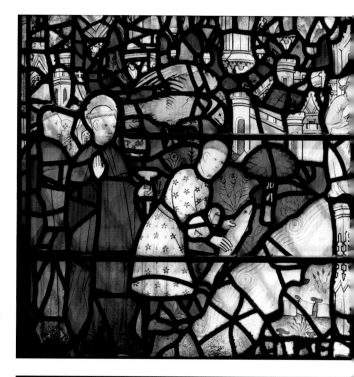

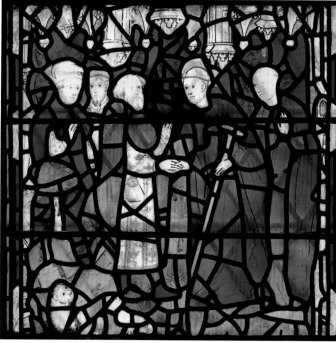

85 St Cuthbert receives a fish from an eagle (s7).

86 St Cuthbert greets a nobleman (s7).

THE END OF THE MIDDLE AGES

B
Y THE fifteenth century some of the earliest stained glass in the Minster, including the original thirteenth-century glazing of the transepts, must have been showing signs of wear and tear. The widening of the choir at the end of the fourteenth century had resulted in the loss of a window in the two transept chapels on either side of the crossing, dedicated to St William (south side) and St Nicholas (north side). Further damage was no doubt sustained as a result of the fall of the central tower in 1405 and the reconstruction work that followed. By c.1430 this building work was drawing to a close and attention turned to re-glazing the transept chapels.

Treasurer Robert Wolveden (1426–32), who had already contributed to the glazing of the choir, contributed here too. His name and coat of arms appear in both the chapels of St William and St Nicholas (s11 and n11), suggesting that the re-glazing programme began at the crossing and moved outwards. In 1434 the fabric rolls record payments for new stanchions for the windows of these chapels, which were described as newly glazed. The windows were probably therefore paid for from the £20 bequeathed by Wolveden in his will. Other donors included Isabella and John Saxton, who kneel before St John the Baptist in window s14. In the north transept the arms of Archbishop Scrope (window n13) may reflect the patronage of John, 4th Lord Scrope of Masham (1418–55), who was buried in the Scrope chapel.

Despite the involvement of a number of different donors, the glazing of the transept chapels resulted in a coherent iconographic programme. Each one was provided with images in glass appropriate to the dedication of its altar, perhaps renewing an image cycle first established in the thirteenth century. Those on the south side are best preserved and depict St William (s11), St Michael (s12 [87]), the Archangel Gabriel (s13), St John the Baptist (s14) and the Virgin and Child (s15). On the north side only the figures of St Nicholas of Myra (n11) and St Stephen (s12) are fifteenth century. St George (s16 [95]) and St Oswald (s17) on the south side and St Laurence (n13), St Paul (n14) and St Peter (n15) on the north are all by the firm of C.E. Kempe & Co (1899–1902), although they replicate medieval figures recorded there in the seventeenth century by James Torre.

The figures in the transept chapels lack some of the refinement of those in the choir, and rely on a great deal of white glass, richly silver stained. They are set directly into star-patterned diamond quarries rather than against deep-coloured backgrounds, perhaps indicative of some financial restraint, although they also preserve the lighter style of glazing first favoured in this part of the building in the thirteenth century. Although they stand on projecting plinths with tiled pavements, there are no architectural canopies.

87 The archangel Michael in s12. The re-glazing of the transept chapels in the 1430s was on a modest scale, perhaps executed by the workshop of John Chamber the Elder.

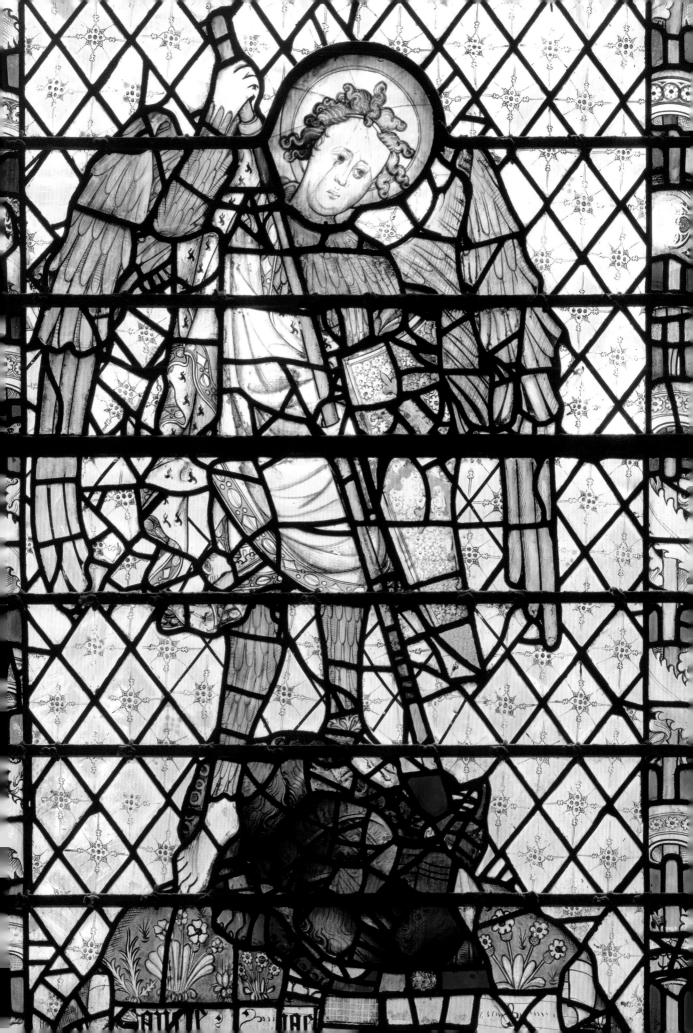

There are also signs of economy in the execution of the eight windows of the lantern tower (L/T N1–N4 and L/T S1–4), in which 48 panels depicting variations of the crossed keys of St Peter are arranged in two registers, above and below the transoms. Each pair of keys is surrounded by a wreath of foliage with an entwined scroll. Coloured glass is used sparingly, to set off the crossed keys, and the panels are rather boldly executed to make them as legible as possible [88]. In 1471 a team of eight glaziers, led by Matthew Petty, was paid 1s per panel. Petty had been working for the Minster since at least the mid-1440s. Some of the glass bought for this project, probably the white, is specified as being English. The Dean and Chapter were funding this work from their own resources and the commission may have been rushed in order to be completed in time for the consecration of the Minster on 3 July 1472. While economy may have determined the use of cheaper white glass, it was

88 The arms of St Peter by Matthew Petty, made for the lantern tower windows in 1471 for the Dean and Chapter at a cost of 1s per panel.

also important to ensure that the crossing was well lit by the lantern above.

The original glazing of the south transept rose window and the windows of the south wall probably survived into the early sixteenth century. The rose window was then re-glazed with glass decorated with stems bearing double roses often said to represent the union of the warring houses of York and Lancaster, brought about by the marriage of Henry VII and Elizabeth of York in January 1486. Henry VII visited York in April of the same year and, although it is unlikely that the window could have

89 The rose window (S16, c.1486–1500). The white and red Tudor roses may be a reference to the union of the warring houses of York and Lancaster in the persons of Henry VII and his queen, Elizabeth of York, married in 1486, although roses have strong Marian associations.

90 St Peter and St Paul in s21 were made early in the sixteenth century and repaired in the eighteenth century by William Peckitt.

been made in time for this visit, it may well have been the catalyst for its creation [89]. However, while the window may have been intended to offer an allusion to the marriage that helped to stabilise the Tudor monarchy, the rose was also widely associated with the Blessed Virgin Mary. Until *c.*1796, window s23 below the rose contained an image of the Virgin and Child and a memorial panel to glazier and Lord Mayor John Petty (d.1508), son of Matthew. It was probably made by the family firm, then led by Robert Petty. It is possible that the Pettys were also responsible for the rose window and for the figures of St William, St Peter, St Paul [90] and St Wilfrid that survive in the windows immediately below the rose and above the south door (s20–s22).

It is fitting that the history of the medieval Minster's *in situ* glazing, which began in the south transept, should also finish there. While it could be argued that by the sixteenth century the most innovative work in English stained glass emanated from London rather than York and was transformed by the influence of immigrant craftsmen, it is clear that the glaziers of York continued to prosper. John Petty and his wife were admitted to the prestigious Corpus Christi Guild and in 1508 he reached the pinnacle of civic government, serving as Lord Mayor, the only glazier ever to achieve this distinction.

AFTER THE REFORMATION

B Y THE early sixteenth century almost every window in the Minster had been filled with medieval glass, leaving very few opportunities for glass painters of successive generations. Furthermore, the religious changes of the Reformation severely reduced the demand for religious stained glass and in places resulted in its removal and destruction. There is little evidence of serious iconoclasm directed against the Minster's windows, although the city's monastic and friary churches were not spared. The major casualties in the Minster were the objects associated with the cult of St William. In October 1541 the silver-gilt head shrine was broken up and both the late fifteenth-century marble shrine base in the choir and the fourteenth-century tomb-shrine in the nave were dismantled. In the reign of the overtly Protestant Edward VI images in stained glass were proscribed in injunctions against superstitious imagery for the first time, but in the Minster it was the plate and the vestments rather than the windows associated with the old religion that were swept away.

Some damage to stained glass was sustained in the summer of 1644 during the Civil War siege of York. The Royalist congregations in the nave were disturbed by the noise of the Parliamentarian siege guns and by the occasional bullet that is said to have come through a window and bounced from pillar to pillar. The city surrendered in the middle of July, and the historic fabric of the city and the Minster were preserved thanks to the intervention of the Parliamentary commander, Thomas, Lord Fairfax, a Yorkshireman and a lover of antiquities. The Minster did not escape entirely unscathed, although it was not subjected to the vandalism suffered by Lichfield, Peterborough or Durham cathedrals. Many of its brasses were lost, pulled up for their scrap value, and some damage to glass and sculpture in the Chapter House may be attributable to this period. Torre described one window at the west end of the nave aisle as having been removed 'during the late troubles'. However, over £1,000 is said to have been spent on the Minster fabric during the Interregnum – Torre recorded the date 1658 in one of the Chapter House windows – and the overall impression conveyed by late seventeenth-century antiquaries is of a Minster filled with medieval glass that continued to command their interest and admiration.

In the years after the restoration of the Monarchy in 1660, repairs were made to damaged roofs and windows. Sir John Petty's memorial window in s23 had been restored in 1662 by the glazier Edmund Gyles (1611–76). In the 1690s further repairs to the Chapter House windows were undertaken by members of the Crosby family. Very little new glass was commissioned, however. In 1691 an armorial of Archbishop Lamplugh [91] in s6 was made by Henry Gyles (1645–1709), son of Edmund, the only substantial surviving relic in the Minster of the work of this largely self-taught York glass painter, the most important stained glass artist of his generation. The technique

91 The arms of Archbishop Lamplugh (1688–91), made in 1691 by Henry Gyles (s6).

THOMAS LAMPLUGH ARCHIEPISCOPUS EBORACENSIS OBIJT V^{to} DIE MAIJ A° 1691

92 St Peter by William Peckitt (s24). The figure was installed in 1768, replacing an earlier one that had deteriorated badly. Sir James Thornhill provided the cartoon.

employed is very different from that seen in the medieval windows. Transparent coloured enamels were applied and fired onto white glass, largely eliminating the need for pot-metal coloured glass. In the case of the Lamplugh shield, coloured enamels were used only sparingly and some have flaked away leaving the panel dominated by the more durable silver stain.

By the middle of the eighteenth century the most prominent practitioner of enamel glass painting was William Peckitt of York (1731–95), the self-taught son of a fellmonger (a dealer in animal hides) from Husthwaite, whose windows were installed in churches, cathedrals and colleges throughout the realm. He was also a lifelong experimenter in the techniques of his craft, conducted in his Micklegate workshop, famed for the exceptional quality of his ruby stain. Throughout his career Peckitt enjoyed the patronage of Dean John Fountayne (1747–1802) and as a result was employed both to repair ancient glass and to supply new windows for the Minster. Evidence of his restoration work can still be seen in the tracery lights of a number of nave windows [29]. Good quality pot-metal glasses suitable for stained glass were in short supply and the dates in coloured glass in the nave (for example, 1789 in s33, 1779 in n27) are in rather bright colours, supplied by Peckitt and installed by the Minster's own glaziers. In 1757 Peckitt supplied new painted glass to make good deficiencies in the west window, including new heads. In the following year figures of St John the Evangelist and St Peter were installed in the place of donor figures in the base of n30 and s36. The lower half of Eve tempted by the serpent was inserted in nave window s30 in 1782. In 1765 Peckitt had painted a new west window for the chapel of New College, Oxford, reluctantly accepting the displaced medieval glass in part payment. The exact date of its insertion in York Minster is not known, but it was probably installed in s8 in the 1780s, with additional glass supplied by Peckitt to make the medieval panels fit their new location [61].

Peckitt's most significant work in the Minster is the series of figures in the south transept (s18 and s19, s23 and s24). The earliest figure, that of St Peter, was originally installed in 1754 but proved to be technically deficient, and in 1768 the badly flaking figure was replaced free of charge. The new St Peter [92] was made from a cartoon by Sir James Thornhill, first used in 1766 in Peckitt's now lost west window of Exeter Cathedral. In 1790 Peckitt painted two further figures, of Abraham (signed and dated 1790) and Solomon (signed but not dated [93]). The figure of Moses, which completes the quartet, is signed and dated 1793 and, like the figure of Abraham, was taken from a design of 1774 originally prepared for the chapel of New College, Oxford, by Biagio Rebecca. Although in 1791 and 1793 Peckitt supplied new painted repairs for the transepts, including the rose window and s21, the figures of Abraham, Solomon and Moses were not installed during his lifetime. Peckitt bequeathed Abraham and Solomon to the Minster in his will; it is a mark of the Dean and Chapter's esteem for the 'late ingenious Mr William Peckitt' that the figure of Moses was purchased from his widow. They display his exceptional mastery of the enamel-painting technique and also illustrate the importance of the handling of ancient glass to the development of the skills of eighteenth-century glass painters. An echo of New College is found not only in the reuse of cartoons, but also in the interesting adaptation of New College's medieval canopy designs for use in an eighteenth-century version of a Gothic architectural setting.

93 King Solomon by William Peckitt, *c.*1790, bequeathed by the artist at his death and installed posthumously in s19.

Solomon rex.

THE NINETEENTH
AND TWENTIETH CENTURIES

Opposite

94 Painted restorations of the early nineteenth century alongside John Thornton's glass painting of 1405–8 in panel 9e of the Great East Window.

95 St George (1890) by the studio of C.E. Kempe & Co. (s16).

ALTHOUGH York Minster was studied and admired by stained glass artists of the nineteenth-century Gothic Revival, it offered them few opportunities to display their talents. Although many windows of exceptional quality were produced in the nineteenth century, the Minster can boast no great window by one of the masters of the period. In 1862 a series of memorial windows by the firm of Clayton & Bell was installed in the King's Own Yorkshire Light Infantry (KOYLI) chapel (windows n19–n22); this was removed in 1945 to make way for the medieval glass from St John's, Micklegate. The windows opposite of 1899–1902, by the firm of C.E. Kempe & Co., have already been mentioned. Their style is broadly sympathetic to the fifteenth-century figures they complement, although the figures of Sts Laurence, Paul, Peter, George [95] and Oswald are rather more richly dressed than their medieval companions.

For the most part, the contribution of the nineteenth and twentieth centuries has been in the restoration and care of the Minster's medieval heritage. This story began in the 1820s with the removal of the Great East Window to allow stone repair. Between 1824 and 1827 the window was completely re-leaded – probably for the first time since its creation – during which the glaziers introduced some sympathetically painted repairs in an attempt to maintain the legibility of the narrative [94]. Following the nave fire of 1840 the Newcastle glass painter William Wailes (1808–81) was employed at the expense of his more eminent contemporary, Thomas Willement (1786–1871), the preferred choice of Minster architect Sydney Smirke (1798–1877). Wailes's work was confined to patching and the replacement of some of the damaged shields in the clerestory. His work as a restorer is perhaps better judged in All Saints, North Street. During the 1844–5 restoration of the Chapter House, also under Smirke's direction, the restoration of the east window was entrusted to the York firm of John Joseph Barnett (1786–1859), while Willement was entrusted with the decoration of the vault. Barnett made careful tracings of the medieval glass, replacing those fragments that he felt could not be saved. This meant returning a facsimile rather than a medieval window and the process was thankfully curtailed [96]. This sort of drastic restoration was only just beginning to be perceived as inappropriate and Barnett's efforts were favourably received by his contemporaries. The Barnett panels were removed from the Chapter House in 1959 and are now located in the nave clerestory (N19, N20, S21 and S22).

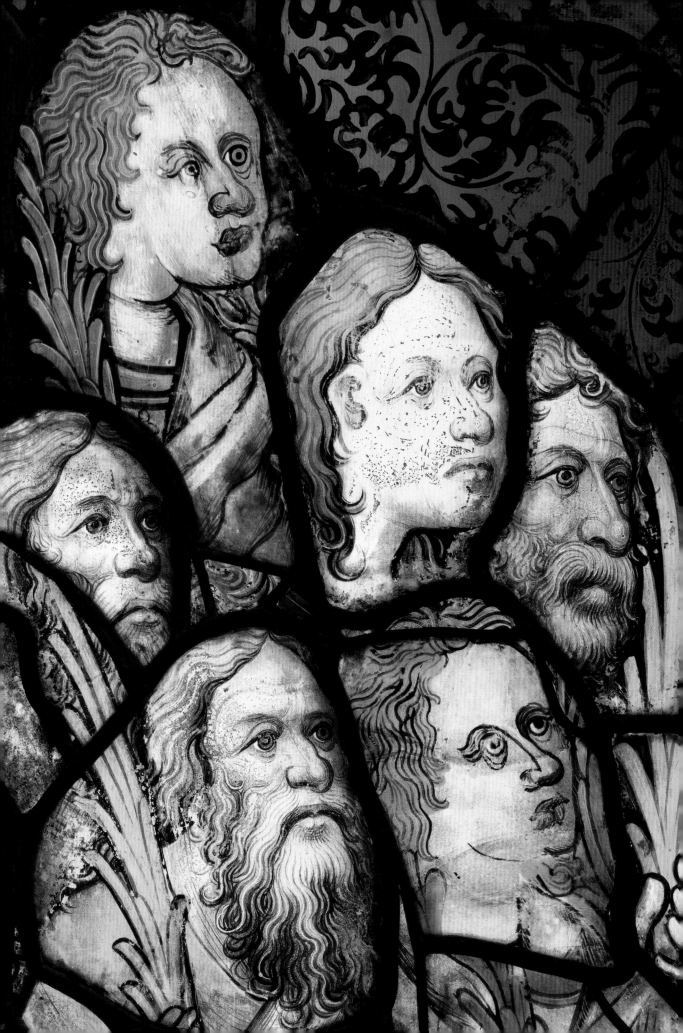

96 An 1844–5 copy by John Joseph Barnett of the late thirteenth-century entombment of Christ from the Chapter House east window. The panel is now located in the nave clerestory (S22).

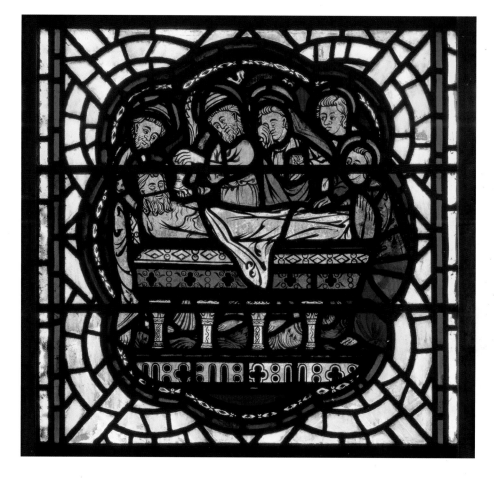

A more cautious approach was adopted for the restoration of the St Cuthbert window in 1887 and the St William window in 1895, both restored by the York craftsman and glass historian J.W. Knowles, father of antiquary and historian J.A. Knowles, author of one of the most important works on York's medieval stained glass. Some new glass was introduced into the windows but not at the expense of the medieval material, and the reordering was undertaken according to scholarly advice and only after careful examination of the panels. This collaboration of craftsmanship and scholarship is the basis on which modern conservation programmes proceed. It is all the more surprising, therefore, that in 1903 the restoration of the Mauley window in the nave (s32) by the London firm of Burlison & Grylls resulted in the creation of a near-facsimile of the medieval window for reasons which remain unclear. It is nonetheless a superb copy of what pre-restoration photographs show to have been a heavily corroded window, and recent re-examination of the window suggests that there is still an appreciable amount of medieval glass remaining. Perhaps most importantly in terms of the future safeguarding of the windows, in 1861 York Minster was one of the first buildings in Europe to be provided with external protective glazing, covering the Great East Window, the West Window and the Five Sisters window (n16), against 'the products of combustion' in the age of the ubiquitous coal fire. This commitment to protection was part of a concerted programme of stained glass restoration that began shortly before the First World War, cut short once it became clear the war was certainly not going to 'be over by Christmas'.

If the advent of the Industrial Revolution presented a threat to stained glass in the form of airborne pollution, the advent of twentieth-century industrialised warfare raised the spectre of airborne bombardment. In May 1916 the city suffered a Zeppelin

97 The Crucifixion, c.1550, originally made for the church of St Jean in Rouen and imported into England in 1806 for installation in St Mary's Rickmansworth. In 1952 Dean Eric Milner-White acquired the glass for York Minster (s6).

attack and the removal of 22 Minster windows to 'dugouts' under the city walls in the deanery garden had been achieved by 1918, although no attempt was made to remove the largest windows. With the return of peace, Dean Foxley Norris (1917–25) launched a major new fund-raising campaign in 1920, intended to restore 70 windows (excluding the Great East Window, St William and St Cuthbert windows), a project vigorously pursued by Dean Lionel Ford (1925–32), founder of the Friends of York Minster. By 1931 Chancellor Frederick Harrison was able to report that with the return of the west window, this programme was almost complete. The glaziers were criticised for some of their cleaning techniques and for their approach to leading, but were actually rather conservative in their approach, re-leading panels more or less as they found them, introducing plain modern glass of the appropriate colour only as a means of stopping up actual holes.

98 A wren hunts a spider. One of the most famous and best-loved pieces of stained glass in York Minster, this tiny quarry in the Zouche Chapel was rescued from obscurity in 1952 by Dean Milner-White.

Opposite

99 Ervin Bossanyi began his artistic career in his native Hungary. Fleeing Nazism and anti-Semitism in Germany, he settled in England in 1934. These panels, made in 1944, exemplify both his distinctive style and his consummate craftsmanship; they were installed in Zs2 in 1975.

A more concerted effort to remove glass to safety began at the outbreak of the Second Wold War, when 80 windows were taken down and stored in secret locations in the Yorkshire countryside. In 1941 Dean Eric Milner-White (1941–63) arrived in York from King's College, Cambridge, where he had taken an active part in stained glass collecting and restoration. The Minster offered him a far larger canvas and even before the war had ended, restoration work had resumed, starting with the Great East Window. Thirteen windows were re-installed in 1945, but as time progressed the pace of return slowed as the Dean and a team of three glaziers – Oswald Lazenby, Herbert Nowland and Peter Gibson – undertook more and more restoration and reordering. In contrast to the work of the earlier generation, Dean Milner-White promoted greater levels of reorganisation of the stained glass panels, sometimes rediscovering lost medieval compositions, but in many instances reordering medieval pieces in an arbitrary manner with little antiquarian or art-historical research. He unwisely dismissed the invaluable testimony of the great seventeenth-century antiquary James Torre in a few words: 'Alas that he did not better understand what he was describing'.

Milner-White also enriched York Minster's stained glass collection. With the help of the Friends of York Minster, for whose annual report he wrote exciting accounts of the work of the Minster glaziers, he acquired some very important sixteenth-century panels, glass alienated from Rouen churches during the French Revolution (see n3, n29, s3 and s6 [97]). English panels of York interest were acquired for the east window of the Zouche Chapel (Z1), which was also enriched with interesting and important pieces of glass rescued from the 'glaziers' bank' of discarded Minster fragments [98].

Milner-White also actively promoted the revival of modern stained glass in York, encouraging the prolific stained glass artist Harry Stammers (1902–69), whose work can be seen in s9, to establish a workshop in the city. The most notable modern glass in the Minster, however, is the work of Hungarian émigré artist Ervin Bossanyi (1891–1975), whose two panels depicting St Francis, made in 1944, are also located in the Zouche Chapel (Zs2), installed in 1975 as a tribute to Dean Milner-White, who had promoted his work at home and abroad [99].

THE YORK GLAZIERS TRUST
1967–2017

B Y 1961 the end of the enormous task of restoring and re-installing the Minster's windows removed for wartime safeguarding was in sight. Dean Milner-White was anxious to ensure that the skills developed in the service of the Minster should be preserved and made available to the wider world, through the creation of a national charitable trust devoted to stained glass conservation in the service of York Minster and other locations of national importance for historic stained glass of all periods. He began to encourage other custodians of historic glass, starting with churches in the city of York, to bring their projects to the Minster workshops. The Dean did not live to see his plan realised; it was Dean Alan Richardson (1917–74, Dean 1964–74) who presided over its implementation.

With the help of the Pilgrim Trust, the York Glaziers Trust was inaugurated on 20 July 1967, with former apprentice Peter Gibson (1929–2016) as its first Superintendent. The inaugural trustees included the Dean of York, the Secretary of the Pilgrim Trust and the Vice-Chancellor of the University of York. The Trust was established to provide expert conservation and maintenance of the Minster's windows, to provide a comparable service to other historic sites throughout Britain and to be a centre of excellence in training, research and education. It has remained committed to these objectives for the past half century. In the same period York has emerged as

100 Peter Gibson (centre), overseeing work on panels from the nave clerestory.

101 Panels being removed from the Great East Window for conservation, 2008.

102 Conservators at work cleaning and glass-painting in the York Glazers Trust, 2016.

an international centre of stained glass scholarship. Stained glass studies were part of the University of York's academic agenda from its inception in 1963 and it is no accident that Dean Milner-White was an influential figure in the campaign to establish a university in the city. In the intervening years scholars from the university have contributed substantially as art-historical consultants and members of key advisory committees, including the St William Window Advisory Group and the East Window Advisory Group. Conservation and scholarship are brought together in the international Corpus Vitrearum, which has its British headquarters in the University. The Trust observes the Corpus Vitrearum's international guidelines for stained glass conservation in tandem with other key international charters for conservation and cultural heritage protection. In the same period the discipline of stained glass conservation has been transformed from a purely craft-based process to one in which craft, materials science, art history and conservation ethics are combined. The Trust has evolved accordingly, becoming one of the largest specialist studios of its kind in Europe, a centre of innovation and excellence in practice and in training, regularly welcoming interns and students from all over the world.

During the last 50 years the Trust has worked at nearly 500 locations throughout Great Britain, in addition to working on numerous Minster windows. Milestone projects at the Minster have included the conservation of the nave clerestory in the 1980s [100], the rescue and conservation of the south transept rose window following the terrible fire of 1984, the conservation and protection of the Great West Window in 1988, the full conservation of the St William Window (1998–2007) and, most recently, the conservation of the Great East Window (2011–16 [101, 102]). This was part of a much larger project of conservation, interpretation and public engagement, *York Minster Revealed*, achieved by the Chapter of York in partnership with the Heritage Lottery Fund and the York Minster Fund. Collaboration and exchange between conservators, custodians, scholars, theologians, fund-raisers and the public underpins the care of stained glass at York Minster, securing it for the benefit of future generations.

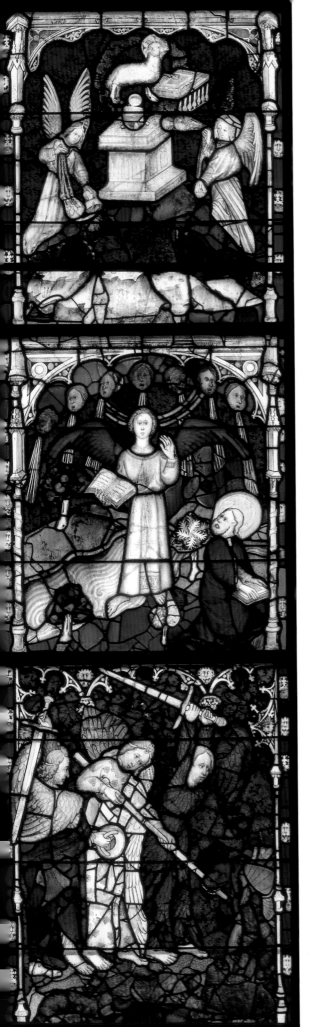

FURTHER READING

Sarah Brown, 'Our Magnificent Fabrick':
 An Architectural History of York Minster c.1220–1500
 (Swindon 2003)

Sarah Brown, Apocalypse: The Great East Window
 of York Minster (London 2014)

Thomas French, York Minster: The Great East Window
 (Oxford 1995)

Thomas French, York Minster: The St William Window
 (Oxford 1999)

Thomas French and David O'Connor, York Minster:
 The West Windows of the Nave (Oxford 1987)

J.A. Knowles, Essays in the York School of
 Glass-Painting (London 1936)

Christopher Norton, 'Richard II and York Minster',
 in Sarah Rees Jones (ed.), The Government of
 Medieval York, Borthwick Studies in History 3
 (York 1997), pp. 56–87

Christopher Norton, St William of York (Woodbridge
 2006)

Christopher Norton, 'Richard Scrope and York
 Minster', in P.J.P. Goldberg (ed.), Richard Scrope:
 Archbishop, Rebel, Martyr (Donnington 2007),
 pp. 138–213

Christopher Norton and Stuart Harrison,
 York Minster: An Illustrated Architectural History
 627–c.1500 (York 2015)

D. O'Connor and J. Haselock, 'The stained and
 painted glass', in G.E. Aylmer and R. Cant (eds),
 A History of York Minster (Oxford 1977), pp. 341–64

GLOSSARY OF TERMS

CALME
The term used to describe the grooved H-profiled lead strips used to hold pieces of glass in place in stained glass panels. The lead strips are soldered at the intersections to make a strong network of glass and lead. The word is derived from the Latin word *calamus* meaning 'reed'. Medieval window leads were cast in moulds in relatively short lengths and the post-medieval practice of re-leading windows means that medieval window lead is now rare.

CARTOON
The full-size working drawing from which the craftsmen made a stained glass panel. For much of the medieval period this was drawn up by the master glazier on the whitened surface of a trestle table, which served as a workbench and cartoon combined. Only in the mid- to late fifteenth century did paper cartoons replace the glazier's table, making it far easier for full-scale drawings to be stored for reuse.

GRISAILLE
Derived from the French *grisâtre* meaning 'greyish', this term is used to describe a non-figurative form of glazing which relies heavily on the use of clear glass, usually decorated with foliage designs in brown or black glass paint. This can be in the form of repeated geometric pieces (squares, rectangles or diamond quarries), or in more sinuous concentric shapes. Coloured glass is either absent or used only very sparingly.

GROZING (IRON)
Medieval glaziers shaped their glass using an iron tool called a grozing iron, a narrow, flat iron with notches cut in the end. This was used to chip off small flakes from the edges of the glass fragment. The grozing iron left a distinctive 'nibbled' and slightly chamfered edge.

LANCET
A single tall, undivided window opening.

MULLION
The vertical stone division in a window tracery.

OCULUS
A round window opening without stone subdivisions.

QUARRY
A small geometrically shaped glass piece, most commonly in a diamond or lozenge shape, although squares and rectangles can also be found. They are leaded up in a repetitive design to create a simple form of decorative glazing, or they can be used to fill in the background behind a figurative or narrative scene. Quarries can be unpainted or decorated with a foliage or figurative motif.

SILVER STAIN/YELLOW STAIN
A compound of silver nitrate which, when applied and fired to the surface of the glass, turns the glass yellow. This colour can vary from a pale lemon yellow to a dark brassy orange. It is usually applied to the exterior surface of the glass. It began to be used all over Europe early in the fourteenth century.

TRANSOM
The horizontal stone divisions in a window tracery.

VIDIMUS
The small-scale sketch design for a stained glass window. It is thought that this would have been attached as a certified design to the written contract for the making of a stained glass window. The few that have survived include, in some instances, instructions, amendments and variations to the original design, suggestive of a discussion process between designer and client. Some are squared up for transfer to a full-size cartoon. The word is derived from the Latin meaning 'we saw'.

WHITE GLASS
Glass uncoloured by the addition of any metallic oxide colourants (which creates a 'pot metal' glass). In practice, medieval glass is rarely 'white', as impurities in the sand used in glass manufacture imparted impurities to the molten glass mix, most commonly in the form of naturally present iron, which gives glass a greenish tint.

INDEX

Figures in **bold** refer to the illustrations

Abraham, 92
Absalom, 67
Agatho, Pope, 76
Aldfrith, King, 76
Amos, 62, **63**
Andrew, St, 36, **54**
angels, **11**, **18**, 30, **56**, **57**, **68**, 69, **71**
Annunciation, 47, 52, 55, **56**
Apocalypse, 68–9, **72**,
apostles, **18**, 31, **51**, 52, **62**
Ascension, 47, 52

Balliol: John: arms, 28
Barnett, John Joseph: restoration, 46, 94, **96**
Beaufort, Cardinal Henry, **78**, 84, **84**
Bek, Bishop Anthony: arms, 44, **45**
bell-founding, 39, **39**, 48
Benedict, St, **14**, 15–16
borders, **9**, 11, 16, 22–3, 26, 37, 39, 41, **42–3**
Bosa, St, 52, 76
Bossanyi, Ervin: St Francis panels, 98, **99**
Bouesdun, Thomas, 50, 55
Bovill, Archbishop Sewal de, 22, 52
Bowet, Archbishop Henry, 76, **77**, 81, **81**, 82–4
Browne, John: drawings, 23, **23**, **26**
Burgh, John, 62, **63**, 65
Burgh, William, 65
Burlison & Grylls, 36, 96

canopies, 37, 39, 46, 47, 60, 62, 75, **78**, 86
Ceolwulf, King, 76
Chad, St, 20, 52, 83, **83**
Christopher, St, 49, **54**, 55
Clare arms, 42, **43**, **44**
Clayton & Bell, 94
Colchester, William, 74, 81–2
Coronation of the Virgin, 47, 52, **52**
Creation, 67, **68**
Crosby family, 90
Crucifixion, 42, 52, **97**
crypt, 10, 11, 60
Cuthbert, St: window, 74, 75, 84, **84**, 85, **85**, 96, 98

Daniel, 15, **15**, 62, **63**
Dean and Chapter, 47, 55, 65, 67, 74, 77, 88, **88**, 92
Dene, Peter de, 37–8, **38**, 39, Denis, St, 42

Eadberht, King, 76,
Ecclesia, 30–1
Edmund, St, 29–31, 42, 47

Edmund Rich, St, 31
Edward the Confessor, St, 31, 58, **59**, 60, **61**, **70**
Edward I, King, 31, **32**, **33**, 37, 44, 46, 48, **80**; arms, **27**, 28, 44
Edward III, King, 42, 58, **70**, 76, 84
Edwin, King, 8, 30
Egbert, St, 52
Eleanor, Queen, 31
Eleutherius, Pope, 76
Entombment of Christ, **96**
Eve, 92

Fitzwalter, Sir Robert: arms, 48
Five Sisters, 15, **15** (detail), 20, **21**, 22–3, **23**, 96
foliage, 10–11, 16, 22–3, 26, **26**, 30, 52, 88, 103
Ford, Lionel, 98
Francis, St: panels, **98**
Friends of York Minster, 98

Gabriel, Archangel, 56, 86
George, St, 86, 94, **94**
Gibson, Peter, 7, 98, 100, **100**
Glazier, Thomas, 62, **64**
 Manasseh figure, **64**
Gloucester, Humphrey, Duke of, 84
God the Father, **67**–8
Great East Window, 6, 7, 58, **59**, 60, **60**, 65–7, **67**, 70, **72**–**3**, 74–6, 78, 94, **95**, 96, **96**, 98, 101, **101**, 103
grisaille, **18** (detail), 19, **19**, 22–4, **23**, 26, **26**, 37, 42, 46, **56**, 103
Grosseteste, Bishop Robert, 31
Gyles, Edmund, 90
Gyles, Henry, 90; armorial of Archbishop Lamplugh 90, **91**

Habakkuk, 15, **15**
Henry IV, King, 65, **70**, 74, 76, **76**, 78, 80, 81, **81**, 84
Henry V, King, 76, 84
Henry VI, King, 84–5
heraldic window, 38–9, **38**
heraldry, 27, **27**, 31, 37, **43**, 44, 74–6
Heritage Lottery Fund, 101
Herodias, **29**

James the Great, 47, 60, **61**
Joachim, 55
John of Beverley, St, 20, 30, 51, 76, 82, **82**,
John of Gaunt, 84,
John the Baptist, St, 29–30, **29** 36, 86
John the Evangelist, St, 36, 52, 52, **53**, 60, **61**, 92

Katharine, St, 26, 29–30, 37, **38**, 52
Kemp, Cardinal John, 84–5
Kempe & Co, C.E., 86, 94:
 St George, **94**
Knights Templar, Order of, 38, 41
Knowles, J.A., 65, 96
Knowles, J.W., 41, 85, 96

Lamplugh, Archbishop: arms,
Lancaster, Edmund, Earl of: arms, 90–2, **91**
Langley, Dean Thomas, 64, 81, 84–5, **84**
Langtoft, William, 41, **41**
Last Judgement, 11, **11**, 16, **18**
Laurence, St, 42, 55, 86, 94
Lazenby, Oswald, 98
Lucius, King, 76

Manasseh, **64**
Margaret, St, 29–30, 52
Martin of Tours, 15
Martyrdom window, 42, **43**
Mary Magdalene, St, 30
Massacre of the Innocents, **54**
Mauley window, 36–7, **37**, 96
Maxentius, Emperor, **38**
Michael the Archangel, 86, **87**
Milner-White, Eric, 7, 29–30, 48, **97**–8, 98, 100–101
Miraculous draught of fishes, The, **12**
Moses, 30, 92
Mowbray arms, 42, **43**

Nativity, 47, 52
New College, Oxford 62, 92
Nicholas of Myra, St, **14**, 15, 29, **29**, 36, **36**, 83, **83**, 86
Nowland, Herbert, 98

Oswald, St, 20, 30–1, 47, 51, 84, 86, 94
Oswiu, King, 76
Ouse bridge miracle, 78

Passion, 28–9, 31
Paul, St, 28–30, **28**, 42, 52, **54**, 82, 86, 89, **89**, 94
Paulinus, 20, 30, 52, 76, 83, **83**
Peckitt, William, 50, 52, 62, 64, **64**, **89**, 92, **93**; St Peter, **92**
Penancer's window, **40**, 41
Percy family, 44, 77
Peter, St, 8, 28–30, **28**, 41, **41**, 42, 47, 52, 82, 86, 88–9, **88–9**, 92, 94, **92**
Petty, John, 89–90
Petty, Matthew: 88, arms of St Peter, **88**
Philippa, Queen of France, **32**, 33
Pilgrimage window, 41, **41**–2
Pilgrim Trust, 7, 100

prophets, 10, 62, **62**, 64
protective glazing, 96
Pucelle, Jean, 56

quatrefoils, 11, 24, 26, **26**

Rebecca, Biagio, 92
Resurrection, 11, 28–9, 47, **47**, 52
Revelation, 23, 67–9, **69**, **71**
Richardson, Alan, 100
Robert, Master, **52**, 55–6
Ros family, 29, 77
rose window, 22, 88–9, **88**, 92, 101

Saint-Denis, 16
Salome, **29**
Saxton, Isabella and John, 86
Scrope, Lord Henry: arms, 76
Scrope, Archbishop Richard, 66–7, 74, 76, 80–1, 83–5, **84**, 86; arms, **66**
Skirlaw, Bishop Walter 66–7, 74, 77, 84; arms, **66**
Smirke, Sydney, 94
Solomon, 92, **93**
Son of Man, 69–70, **71**
Stammers, Harry, 98
Stephen, St, **33**, 36, 42, 55, 58, 86
Synagogue, 30–1, **31**

Thomas Becket, 10, 20, **26**, 29, 31, 41, 78, 81
Thornhill, Sir James, 92, **92**
Thornton, John, **58**, 65–70, **65**, 74, 78, **80**, **94**

Tree of Jesse, 15–16, **17**, 19, 62
Tunnoc, Richard, 39, **39**, 41, 48

vault paintings, 30
Vincent, St, **33**, 42, **43**
Virgin Mary, 16, **26**, 28–9, 42, **42**, 47, 52, **52**, **54**, 56, **57**, 60, 82, 86, 89

Wailes, William, 94
west window, 34, 49–50, **50**–**3**, 52, 55–6, **64**, 96, 98, 101
Wilfrid, St, 8, 20, 30, 47, 51, 89
Wilfrid II, St, 52, 76
Willement, Thomas, 94
William, St, window 10, 20, 22, 28–30, **31**, 34, 36, 39, **39**, 44, 47, 49, 51, 81–3, **82**, 86, 89–90; window, 74–8, **75**, **76**, **78**–**80**, 82, 85, 96, 98, 101
William I, King, 8, **70**
wine merchant, 48, **48**
Wykeman, William, 62

York Glaziers' Trust, 7, 100–101
York Minster Fund, 101
York, University of, 7, 100–101